HIDDEN HISTORY
of
SOUTHEAST NEW MEXICO

HIDDEN HISTORY
of
SOUTHEAST NEW MEXICO

*Donna Blake Birchell
& John LeMay*

Published by The History Press
Charleston, SC
www.historypress.net

Copyright © 2017 by Donna Blake Birchell and John LeMay
All rights reserved

Front cover: A 1910 Sunday outing at McKittrick Cave, later known as Gray's Cave. *From left to right*: (*standing*) Nora Leck, Fiona Leck and Deatron Campbell; (*seated*) Bert Leck, Jay Leck and their cousin visiting from Pennsylvania, Robert Ezell. *Courtesy of the Southeastern New Mexico Historical Society.*

Back cover, top: Footprints in the pristine gypsum sand at White Sands National Monument located near Alamogordo, New Mexico. Areas outside this site are also used by the Holloman Air Force Base for military training. *HSSNM, Larkham Album #3.*

Back cover, bottom: Surviving eight members of the Jones family pose for this 1919 photograph. *From left to right*: (*standing*) Bruce, Henry, Charles "Nib" and Frank; (*sitting*) Sam, Tom, Bill and Jim. Missing are brother John and sister Minnie, who both died at early ages. *Courtesy of the Southeastern New Mexico Historical Society.*

First published 2017

Manufactured in the United States

ISBN 9781467137812

Library of Congress Control Number: 2016961487

Notice: The information in this book is true and complete to the best of our knowledge. It is offered without guarantee on the part of the authors or The History Press. The authors and The History Press disclaim all liability in connection with the use of this book.

All rights reserved. No part of this book may be reproduced or transmitted in any form whatsoever without prior written permission from the publisher except in the case of brief quotations embodied in critical articles and reviews.

For all the seekers of the past. Thank you for your continued love and support of history and the Land of Enchantment
—DBB.

For Peggy Stokes
—JL

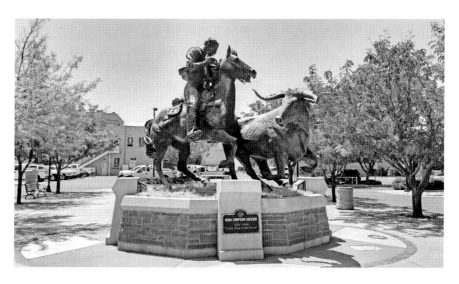

This statue of John Chisum by sculptor Robert Summers located in Roswell, New Mexico, has its own unique hidden history in the form of the bull, nicknamed "Old Ruidoso," who supposedly terrorized the cattle ranges long after his demise. He is one of many mysteries and tall tales of southeastern New Mexico. *Courtesy of John LeMay.*

Contents

Acknowledgements	9
Introduction	11

Part I: Outlaw Days
1. Phenix: Eddy's Wicked Sister	17
2. Gunfights in Seven Rivers	23
3. Bonnie and Clyde Take a Hostage	32

Part II: Campfire Tales
4. Murders on the White Sands	41
5. Ghosts of the Lincoln County Courthouse	49
6. Old Ruidoso: John Chisum's Ghost Steer	52
7. The Petrified Man of the Guadalupe Mountains	61
8. Giant Rattler of the Valley of Fires and Other Big Snakes	66
9. Lost Skeletons and Baffling Bones	75
10. Lost Aztec Treasure of the Capitans	78

Part III: Enchanting Locales
11. Bottomless Lakes, Lost River and Diamond Cave	87
12. Mysteries of White Sands: Giant Footprints, Dinosaur Petroglyphs and the Lady of the Sands	99
13. Hermits of the Guadalupe Mountains	103

Contents

Part IV: The Military in Southeastern New Mexico
14. Military Geoglyphs, POW Camps and
 Forgotten Army Air Fields of Southeastern New Mexico 117
15. The Carrizozo UFO Crash of 1947? 128

Notes 131
Bibliography 133
Index 137
About the Authors 143

Acknowledgements

Donna Blake Birchell would like to thank the following: Samantha Villa—as always my friend, you are thanked first and foremost. None of this would have happened without you. Special thanks go to my dear friend Valerie Cranston, whose notes and fabulous articles were used extensively and greatly appreciated. Thank you for keeping history alive! To my dear family, Jerry Birchell; Michael Birchell and his wife, Sherrie; and Justin Birchell and his wife, Amanda, I could not have gone this far without your love, support and enthusiasm. Also, to my sister-in-law Billie Webster, thank you for being my biggest fan—I truly appreciate you! Much love to you all. Also, I give my undying gratitude to all of those who have touched my life. Your support has sustained me and given me the desire to move forward. I have truly been blessed.

John LeMay would like to thank the following: As always, I'd like to thank the good folks at the Historical Society for Southeast New Mexico (hereby HSSNM in photo credits), namely former director Tina Williams and current director Amy McVay Davis, for their help and support. Located at 200 North Lea Avenue in Roswell, New Mexico, the HSSNM archives building provided the basis for much of this book's research and its extensive photographic collection. I would like to thank treasure hunter Jack Purcell and Mickey Cochran of Go West Marketing for answering questions regarding the lost treasure of Capitan Mountain. And an especially big thank-you goes to my friend Chris Casey, who gave me not one, but four fantastic drawings of Old Ruidoso the Ghost Steer to choose from.

Introduction

Of the different quadrants of the Land of Enchantment, southeastern New Mexico sometimes gets the short end of the stick when it comes to fantastic legend and lore when compared to northern New Mexico. Therefore, sometimes southeastern New Mexico is often thought of more as "Little Texas" rather than an enchanting desert land filled with mystery and intrigue. Even the Spanish conquistadors tended to shy away from this isolated part of the state.

After all, there are quite a few tomes on northern New Mexico's many rich legends, from the Taos Hum to the many wonderful Hispanic folktales from Santa Fe. Even southwestern New Mexico has its share of fantastic tales, chief among them the Lost Adams Diggings, and though lesser known, the Lordsburg Door, where strange things traverse to and fro from a rumored portal in the sky. Though it seems to lack the artsy mystique of other portions of the state, southeastern New Mexico is actually steeped in history as the stage of three of the state's biggest legends—the Roswell UFO crash of 1947, the Lincoln County War/Billy the Kid and the Victorio Peak treasure. None of these will be covered extensively in this tome, as they are far from being hidden history.

To talk a bit about this portion of the state's history, the southeast wasn't vastly investigated during the Spanish exploration of the mid-1500s. Spanish explorer Antonio de Espejo spent some time in the region in 1582 and Gaspar Castaño de Sosa in 1590, but they recorded very little about the area. A few small petroglyphs once existed at Bottomless Lakes State Park

Introduction

depicting the first Spaniards to traverse the Pecos Valley, likely etched into stone by the Mescalero Apache. However, when one of the authors went out to track them down, the overhang they once decorated seemed to have been stripped of its valuable rock art. The petroglyphs' whereabouts are now sadly unknown.

The fact that southeastern New Mexico is sometimes called Little Texas isn't entirely inaccurate, as the area's history is steeped in cowboys, cattle and cattle barons like John S. Chisum. This portion of the state was located along the Goodnight-Loving Cattle Trail, on which cattle were driven from Graham, Texas, to the Indian reservation at Fort Sumner, New Mexico. As such, cattle were the lifeblood of the area, and most of them belonged to John Chisum—known as the "Cattle King of the Pecos"—who drove several thousand head of cattle to New Mexico in 1867 to establish his enormous ranch, which spanned nearly all of southeastern New Mexico.

Chisum was well known across the state for his unique way of making his cattle recognizable and, therefore, not as easy to resell after being stolen by cattle rustlers. In addition to branding his cattle, he also cut their ears down the middle, creating an effect famously called the "Jingle-Bob." So famous was Chisum that John Wayne portrayed him in the 1970 movie *Chisum*, though the real John Chisum never fired a gun or participated directly in the bloodshed of the Lincoln County War, as the Duke does on screen.

In many ways, much of the area's legends and hidden history stems from the bloody Lincoln County War in some way or another, such as tales that one of Chisum's steers was cursed and later became a ghost in the mountains. Of course, many other area mysteries and tall tales stem from other feuds, such as the one involving Oliver Lee, Albert B. Fall and Colonel A.J. Fountain that resulted in the latter's murder. Then there are other legends that likely originated solely from the imaginations of bored cowboys out on the trail, out to outdo one another with tall tales around the campfire. These legends did not stop with the cowboys but continued well into the early twentieth century. For instance, well before UFOs crashed in Roswell, cars went missing in Bottomless Lakes and Lost River, and the most popular urban legends of all claim that what sinks in Bottomless Lakes (including said cars) later resurfaces in the Carlsbad Caverns. And as you will soon discover in the pages ahead, not only has Billy the Kid "slept here" but so have other gunfighters, such as Clay Allison and John Wesley Hardin and, years later, the star-crossed outlaws Bonnie and Clyde. Southeastern New Mexico is also the site of World War II–era hidden history in the form of the many military geoglyphs scattered around this portion of the state.

INTRODUCTION

Further mysteries surround a Carrizozo gas station destroyed in 1947 that has a surprising alleged tie to the Roswell UFO crash; two hermits who lived close to each other in different times; and two towns so wicked, it was a miracle anyone made it out alive to tell their stories.

Our tales are hidden treasures told by the residents who lived through the events. Although they do not carry the weight and importance of historical events like the Trinity Site in Alamogordo or Robert H. Goddard's rocket tests in Roswell, we present these historical gems so that they will be preserved and passed on to the next generation. In fact, this tome has been a dream project for the two authors for nearly seven years now, so we sincerely hope that you enjoy reading it as much as we did putting it together.

PART I

OUTLAW DAYS

I

PHENIX

Eddy's Wicked Sister

Whispers, innuendos and scandal hung over Phenix, a dusty patch of land in the southeastern section of the New Mexico Territory known as just the latest in the long string of Hell's Half Acre towns that had sprung up in the West. Sin clung to every surface of the good town turned bad as it flourished under the desert sun. Gambling dens, brothels and saloons littered every street of the two-mile-square plot of land.

Rising up out of necessity, Phenix had high hopes of becoming a proper town, but her sister town, Eddy (soon to be renamed Carlsbad), was a strictly enforced dry community, which led residents to find access to their libations elsewhere. Phenix arose a little over a mile south, down the dirt road leading out of Eddy toward El Paso, Texas. And thanks to an exclusion of a no alcohol clause concerning this particular piece of land, the town was able to service the drinkers of the region.

Charles B. Eddy, founder of the town that bore his name, was often described as a man with extraordinary charisma and business sense. His vision for the Pecos Valley was one of a utopia—a perfect society living in complete harmony. In order to achieve this lofty goal, a clause was written into each contract for land sold that mandated that the owner would not sell or manufacture alcoholic beverages on the premises. As a teetotaler, the one vice Eddy could not abide was alcohol, from which he was convinced all sin emerged. In Eddy's opinion, opening a bottle of liquor could constitute manufacture, and the failure to adhere to his rules would result in the immediate forfeiture of the property back to the Pecos Valley Town Company—of which Eddy was president.

Eddy modeled his visions after his former home of Colorado Springs, whose city fathers, according to a dissertation by Stephen Dean Bogener, "outlawed the vicious influences of liquor and gambling." The town of Eddy was to become a miniature replica of the Colorado city.

The citizens of Eddy were forced to drink in secret—in back alleys, as one newspaper account stated—taking advantage of the partial cover provided by the frequent dust storms. Drugstores in Eddy began to bring in shipments of whiskey to be transferred into bottles, for medicinal purposes only, of course. The "patients" were even allowed to write their own prescriptions, making these establishments extremely popular. It was a brilliant plan until the powers that be noticed the marked increase in shipments.

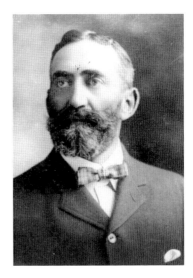

Charles Bishop Eddy was a charismatic man of vision who developed an empire and founded three towns. *Courtesy of Southeastern New Mexico Historical Society.*

Druggist James A. Tomlinson, an Irish immigrant who came to Eddy from the mining town of White Oaks in 1889, was brought up on charges by the Pecos Valley Town Company of not only selling alcohol without a license to the citizens of Eddy but also doing so in such large amounts it was deemed unhealthy for the community. Tomlinson was convicted and fined $500, which he appealed. The case was taken to the Supreme Court of the Territory of New Mexico in August 1893, which upheld the original fine. It took Tomlinson two years to pay it off.

Thus Phenix was born. Lofty dreams came to fruition in the form of opera houses, restaurants and theaters, as well as saloons and gambling houses.

Soon, gamblers, soiled doves and outlaws would brazenly roam the streets of Phenix and tarnish the burgeoning town's dreams and image. Mysterious deaths, fires and rumors of treasure fueled the legend that was to be Phenix. Ed Lyell, Goldie Elliott, Clay Allison, Martin and Beulah M'Rose, John Wesley Hardin and Dave Kemp were just a few of the cast of eclectic characters who either lived in or heeded Phenix's siren call.

Henry A. Bennett built the first saloon and gambling house, called the Legal Tender. The most popular of the many saloons, the Silver King, was owned by C.H. Philbrick and Alfred Rhodes. It had a large

Part I: Outlaw Days

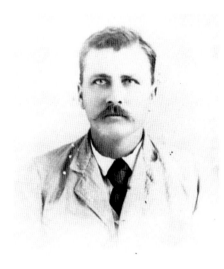

As an outlaw turned lawman, Dave Kemp had his hands in many facets of Eddy County society. *Courtesy of Southeastern New Mexico Historical Society.*

concert hall and was later sold to Ed Lyell and Sheriff Dave Kemp. Nelly Lyell, Ed's wife, served as the madam for over twenty-five soiled doves who were inmates of the crib houses behind the saloon. By 1893, Phenix boasted a population of nine hundred citizens—nearly three hundred were said to be prostitutes. Other saloons in Phenix were the Adobe and the Two Brothers (with which Dee Harkey was affiliated).

Goldie Elliott—a flamboyant resident of Phenix and only one of the many "beer-jerkers" who called the tiny sin city home—was not oblivious to love. When the object of her desire paid particularly close attention to Rosie, another inmate, trouble erupted. The fight between the two women resulted in Goldie being severely injured by the jagged edges of a broken beer bottle. One has to assume the scuffle was quite entertaining for the gentleman involved, as well as the rest of the saloon's clientele. The trial that followed drew a large curious crowd in the small courthouse, and citizens clambered for a good spot to hear the sordid tale. Goldie recovered from her injuries, but both women were assessed a small fine for the court's trouble.

One particularly sad tale of Phenix involves Theodora Guerra, a fifteen-year-old Hispanic girl who was recruited by Madam Nelly Lyell in El Paso, Texas, after hearing that her sister was already living in Phenix. Unbeknownst to Theodora, her sister was a bride of the multitudes. Hired under the pretense of becoming a housekeeper, the girl traveled willingly with the Lyells to start her new job.

Once in Phenix, the situation quickly turned for the worse, with the madam now having the girl far from her Isleta, Texas home and under the debt of her passage to New Mexico. Theodora was put to work as a new entertainer for the bordello. Her sister's love could not cover the shame the young girl felt, and a lethal dose of morphine tragically ended her indenture. Ed Lyell reluctantly paid for her burial, and all the ladies of Phenix attended her funeral. Theodora never saw Isleta again.

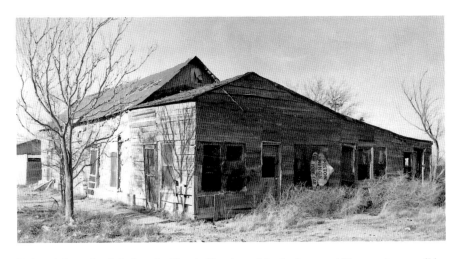

If the adobe walls of the last dwelling in Phenix could talk, they would have quite a sordid tale to tell. *Courtesy of Southeastern New Mexico Historical Society.*

Gunfire was a common occurrence on the streets and within the walls of Phenix. The last remaining dwelling, which met its doom in 1989, bore the scars of many a bullet hole. Fights broke out over poker or faro games, fueled by cheap alcohol.

A stagecoach was robbed by thirty-one outlaws, and a posse closed in on them as they headed to Phenix. It was said seven of the fleeing robbers rode their horses straight into what would be the last building of the sin city, which was used as a saloon and brothel. The remaining twenty-four were left dead or dying after facing the posse on the dusty street.

One of the biggest myths surrounding Phenix is that of a tunnel dug by the men of nearby Eddy for the sole purpose of visiting the gambling dens and pleasure palaces without being detected. The tunnel was said to have stretched from a tavern—the Silver Spur, where the modern-day Motel Stevens stands today—approximately 150 feet to the door of the closest Phenix bordello. Married men interested in partaking in the activities offered could crawl through the tunnel, and no one was the wiser. Evidence of this purported portal to sin has never been found, but ask any old-timer and he or she will verify in a whisper with a sly smile.

Local newspapers reported numerous activities committed by Phenix patrons and residents in a no-holds-barred style. *Eddy Argus* editor Richard Rule considered himself a bit of a poet, and he crafted humorous verse about the progression of the southern hamlet, much to the delight of the townsfolk of Eddy. One such verse harkened the new sinful era:

Part I: Outlaw Days

In story we read of the Phenix of old,
Consumed in the hot breath of fire
Yet quick wining from the red flame and gold,
A new Phenix rose from the pyre.
And so, when our hybrid saloons got a "fire"
Direct from the headquarters last week,
A Phenix was born of disaster most dire,
A beer-check held fast in its beak.

This poem refers to a fire in 1893 that swept through Phenix on a June afternoon. Bennett's saloon, the first structure, was the epicenter, as a match was lit while a porter was filling a demijohn of whiskey from a barrel. The flames were extinguished, but they had already set the ceiling ablaze. The flames spread to the northwest—thanks to the high winds—destroying all of the buildings that lay north of the Legal Tender. Local newspapers reported that nearly 100 Hispanics stood and watched as Phenix burned—most likely due to the poor treatment they had received.

Nothing was saved, including the open safe and the money left on the gambling tables. Whiskey and beer were salvaged from other saloons before they, too, fell victim to the fire. Because water was a rare commodity, it was reported patrons attempted to extinguish the fire by hurling bottles of beer in its direction. Damages were estimated at close to $11,000. It was widely believed this and other following fires of a mysterious nature were deliberately set in an attempt to get rid of the undesirables of Phenix.

Yet another accident involved a great shootout in one of the saloons, resulting in the death of a well-liked barkeep, Argyle Rhodes, not the intended target. The gunman was heard to say after the gun smoke cleared, "He wuddin't even the one I wanted to kill."

Daily accounts of the wicked activities of Phenix, also known as Jagtown, Jagville or Hagerman Town, told of the many murders, disembowelments, brawls, gambling fights, adultery, vagrancy, tramps and loafers that made for easy news stories for the various newspapers of the area. Each issue of the paper would have a snippet of news from Eddy's wicked sister.

One such story involved what was called a "matrimonial epidemic." Since the good townsfolk of Eddy were becoming more and more incensed about the evil happening to the south, and no proper gentleman could travel past the hamlet without being accosted by half-clothed women, something had to be done.

Daniel "Dee" Harkey, deputy sheriff, author and meat butcher. *Courtesy of Southeastern New Mexico Historical Society.*

Enter Daniel "Dee" Harkey, deputy sheriff and part owner of the King Saloon, who was hired to rid Eddy of her southern eyesore. Liberally enacting the Edmunds Act, Harkey set forth to arrest all couples living in sin and bring them to justice. He did this so often that up to five couples—fearing they were to be Harkey's next targets—came to Eddy and were married in one day. Marriage was the only method of escape from prosecution.

Harkey became such a thorn in the side of the brothel owners they eventually decided it might be better to move on to greener pastures—Globe, Arizona, to be exact. With great exuberance, sixteen ladies of the night sporting parasols boarded the Arizona-bound wagon dressed in their fineries, surrounded by their madam, saloon owners and assorted townsfolk, as well as Eddy's early photographer, Fred Stringfellow. A fourteen-piece band escorted the group out of town, playing "Bonaparte's Retreat," which they had renamed, "Dee Harkey's March" in honor of their nemesis. The ladies sang, "Farewell, Dee Harkey, farewell!"

Phenix had mostly met its demise officially only three years after its grand entrance into the desert society, but a few stragglers remained for almost ten more years. Fire, floods and the ravages of time finally erased all but one remnant of the raucous town. The adobe building was the subject of much speculation over time, and it became a private home for many years. Stories of buried treasure prompted many a treasure hunter to sneak into the junkyard surrounding the structure in a futile attempt to get rich quick.

Sadly, Phenix vanished into nothing but a historical memory in 1989, when the last remaining evidence of its existence was razed in the junkyard in which it had resided for nearly one hundred years.

2
GUNFIGHTS IN SEVEN RIVERS

On the windswept plains of southeastern New Mexico, where cattle was king, a small cow town was established in 1867. Along the Goodnight-Loving Trail and home to over one thousand head of John S. Chisum's Jingle-Bob Ranch steers, the mercantile of the town began completely out of necessity as the only source of farm and ranch supplies for 40 miles north to Artesia and 104 miles south to Pecos, Texas, in modern-day calculations.

The first trading post—said to have possibly been made of buffalo hides—was opened in 1867 by William Daken Reed (new information has come to light to substantiate this is his correct name; he has been referred to as Dick Reed in many publications over the years); the second was a couple miles down the road and owned and operated by a Confederate officer, Captain Sam Samson. These served as saloons and trading posts, and the community that sprang up around them became the first Angelo settlement in Eddy County.

Originally graced with the more colorful moniker of Dogtown—due to the large population of prairie dogs that also called that region home—Seven Rivers, or as the early Spanish explorers recognized it, Siete Rios, would not be the official name until 1878. Coincidently, this was also the year the Lincoln County War began, which recruited many of the key players from the Seven Rivers range. Gaining a shady reputation, they were known as the "Seven Rivers Crowd."

The *Eddy Current* reported, "Seven Rivers men just like the sound of bullets, and spoiled for a good fight."

Early Seven Rivers resident Ash Upson brought a sense of class to the rowdy cow town as an attorney and later as Pat Garrett's ghost writer. *Historical Society of Southern New Mexico Collection.*

Other suggested names were Ashland, after citizen, author, lawyer and friend of Pat Garrett, Ash Upson, and a sophisticated Belmont, but Seven Rivers won out in the end.

In 1883, a new town was built a mile west of the original and became known as Henpeck. The reason for this name is unknown, but it appears that the surrounding residents had a feud over rules that led to the separation. This hamlet was unsettled and moved once more, changing its name to White City, after a rancher in the area. This, too, was also short-lived, and by 1900, the original Seven Rivers was a ghost town. The new settlement assumed the Seven Rivers name—after the seven streams that feed into the Pecos River at this point.

Early characters that frequented the wood and adobe saloons in the small village were known to be ruffians, outlaws and all-around bad hombres. It was widely known if you wanted trouble, you would find it quickly in Seven Rivers. The town was widely described in local newspapers as a "village of dozens of hard-core drifters, drovers, gunmen and fugitives."

Zachary Light

One such fellow was the outlaw Zachary Light, who frequented the saloon owned by James "Les" Dow, the sheriff of Eddy, a few miles south. Light, a Texas-born cowhand, was described as a jovial character until he was a few drinks into a drunk. Then he became dangerous. Known as one of the quickest shots in Mason County, Texas, Light was no stranger to gunfights.

On one such drunken episode, Light tangled with Les Dow and received a bullet hole over the left eye for his trouble. Dow was also a crack shot and did not tolerate poor behavior in his saloon.

The date of death on Light's headstone reads April 1890, but recent findings show that he was arrested and charged with theft in September

1890, according to the *Roswell Daily Advocate*. It is possible Light's death came the following April.

Boothill Cemetery in Seven Rivers was soon to have many residents; the first four people in the cemetery died of gunshot wounds. The newspapers used to jest that you could read their paper at night by the light of the gunfire in Seven Rivers. Saloon owners had removable doors at the entrances to their establishments that doubled as stretchers to carry the dead and wounded from the bars to the doctor or undertaker.

Cowboys, fresh off the trail, were notorious for terrorizing the town by racing down the main street shooting off their weapons as they went through.

Hugh Beckwith

One of the more harrowing tales of Seven Rivers actually occurred between two family members. Henry M. (Hugh) Beckwith—a prominent rancher, originally from Virginia and one of the first settlers in the area—was also a member of the Seven Rivers Warriors and fought in the Lincoln County War alongside his son-in-law William H. Johnson and William H. Bonney, aka Billy the Kid.

According to author F. Stanley, Johnson was a hired gun who had come to Seven Rivers to help break up the Chisum ranch. Chisum claimed that his cattle were being rustled by the ranchers at Seven Rivers, including Beckwith, and this started the range war that eventually cumulated in the Lincoln County War. Beckwith had lost two sons to the troubles and was not happy when Johnson, who had already married his eldest daughter and rode for the Murphy-Dolan-Riley faction, attempted to recruit another of his sons into the fight.

Stanley's account has Beckwith, a nonviolent man, holding Johnson responsible for the deaths of his sons who had fought with Johnson in the Lincoln County War and eventually paid the ultimate price for associating with the wrong side. Others paint a different picture of Beckwith, naming him the leader of the Seven Rivers Warriors, a huge thorn in the side of John Chisum and responsible for several deaths during the Lincoln County War era. In 1890, he was found bound and beaten to death after a robbery of his general store in Presidio, Texas.

One story is certain: tensions mounted within the Beckwith household and came to a head when, on August 16, 1878, William "Bill" Johnson

No one died of natural causes in Seven Rivers. Because of this, many of the residents of the cemetery still roam the shifting sands of the desert. *Courtesy of Southeastern New Mexico Historical Society.*

casually mentioned that he had fought on the Union side of the Civil War during dinner one evening. As a Confederate sympathizer, Beckwith could no longer quell his anger. Before Johnson could react, his father-in-law had taken a shotgun and removed his head at the dinner table.

Many decades later, when archaeologists excavated Johnson's grave, they found no skull. Incidentally, the hermit Bob Brookshire was commissioned to carve Johnson's prominent headstone. We know this by his signature on the bottom of the stone.

The Jones Boys

The Joneses were some of the earliest settlers in Seven Rivers, and the family comprised ten children—nine of them boys. The matriarch, Barbara Culp Jones, was known to everyone as Ma'am Jones and served as the closest thing to a doctor the community had at that time. As proprietors of the local trading post and post office, Heiskell and Barbara Jones were in the thick of everyday life in Seven Rivers.

As their sons, John, Jim, Bill, Tom, Sam, Frank, Charles "Nib," Henry and Bruce, grew, many rode for the local cattle outfits, and several became members of the Seven Rivers Warriors. They fought in the Lincoln County War for the Murphy-Dolan faction even though they were great friends with Billy the Kid.

Part I: Outlaw Days

Billy had shown up at the Jones *chosa* (dugout) with no boots and bleeding feet covered in stickers. He relayed a tale of how the Apache had stolen his horse at a ranch in the Guadalupe Mountains, forcing him to walk approximately twenty miles to their doorstep. Ma'am Jones took the young man in—not knowing his identity—and nursed him back to health. For this, Billy protected the Jones family until his death in 1881. Ma'am Jones would frequently tell people that she was the first person to meet Billy the Kid in Lincoln County.

Billy was known to spend quite a bit of time in Seven Rivers with his second family, the Joneses. There he and John would practice target shooting, and Billy—described as graceful as a cat—would show his friend how to trick ride and shoot, much like the tactics the Apache used. The outlaw could pick up a handkerchief off the ground at full gallop—a skill of which he was extremely proud.

John Jones was wounded in the Five-Day Battle and was one of the men who killed Alexander McSween in Lincoln. The Jones boys were notorious

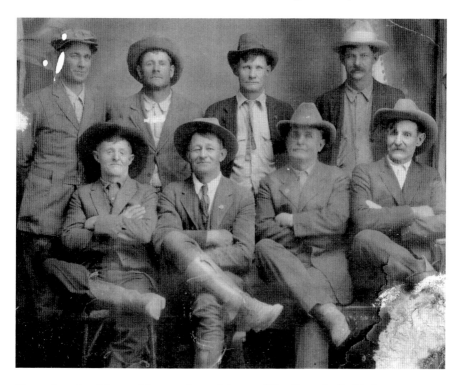

Pictured are the eight surviving members of the ten-sibling Jones family. Each one was a force to be reckoned with. *Courtesy of Southeastern New Mexico Historical Society.*

for their quick tempers and expertise with firearms—a deadly combination in any time. You did not go up against a Jones without the expectation you were not going to survive the encounter. Later in life, the Joneses were credited with capturing three German POWs as they tried to make their escape up Rocky Arroyo.

The Seven Rivers Warriors seemed to have some organizational problems, as members began to turn on one another over time. John Jones and his rustling partner John Beckwith, son of Hugh Beckwith, got into a heated argument in 1879 about the ownership of a particular herd of cattle. Guns were drawn, and Beckwith bit the dust, as Jones was the quicker shot of the two men.

On his way to Lincoln to turn himself in, the twenty-one-year-old Jones stopped at the ranch of fellow Warriors Milo Pierce and Louis Paxton, where he found Pierce lying on a daybed on the porch. Jones shook Pierce's hand and was suddenly surrounded by at least five other Seven River Warriors. They had heard of the altercation with Beckwith, whom they preferred over the hotheaded Jones. As Jones went for his gun, Pierce grabbed his hand—preventing him from moving. Behind Jones was Bob Olinger, a friend and relative of Beckwith's. He drew his pistol, fired and struck Jones with two bullets in the back and two in the back of his head.

In a case of poetic justice, one of the bullets fired into Jones's back went through him and struck Pierce in the hip, crippling the man for the rest of his life.

Olinger made an enemy that day of Billy the Kid, who considered Jones a close friend. Olinger would pay with his life for this ambush, as Billy would soon avenge the death of his friend.

Billy's Gang

A traveler by the name of Andres Gallegos told the *Las Vegas Optic* of another incident that happened in Seven Rivers in January 1884. Several members of Billy the Kid's old gang, including Tom Pickett, Billy Wilson, Pony Wilson and Yank Beale, had arrived in Seven Rivers looking to go on a binge at Bill Griffith's saloon. Whiskey flowed freely, and Gallegos said he was appalled by tales of the outlaws' sordid escapades, which were recounted throughout the afternoon as they became increasingly impaired.

Bored, the outlaws spied a group of Mexican laborers walking up the street and decided to play with them. Beale took the first shot, followed by the rest of the gang. This ghastly ambush resulted in the deaths of four laborers in a flurry of over one hundred rounds of ammunition. By the time townsfolk arrived on the scene, the outlaws were long gone—but only after casually walking back to the saloon for a drink to celebrate the success of their killings.

After forcing Griffith to fill up several pint jars with whiskey, the outlaws escaped town. Although the men were pursued by townspeople, cowboys and ranchers, they safely arrived in Mexico. New Mexico Territory governor Lionel Sheldon offered $500 each—dead or alive—for the return of the perpetrators of this heinous crime.

The laborers were in town to pick up supplies for a nearby irrigation project initiated by Pat Garrett and Charles B. Eddy, and it is still in use in present-day Carlsbad.

In 1885, Seven Rivers was described "as a settlement which boasted saloons, gaming tables, dance halls and painted ladies." This did not sit well with cattle rancher and teetotaler Charles Eddy, who first settled in Seven Rivers and had bigger dreams for the area. The dream consisted of drilling enough water wells and building enough ditches in the town to make it a garden, enticing settlers to buy up the land and make him a rich man.

Seven Rivers citizens were not so enchanted with the idea, so Eddy moved twelve miles downriver and established the town of Eddy. This was the final nail in the proverbial coffin of Seven Rivers. Eddy grew quickly and became the Eddy County seat, luring many from Seven Rivers to abandon their raucous town for the southern "metropolis" of Eddy.

James Barrett

One of the last violent acts in the life of tiny Seven Rivers occurred in July 1893, when Irish-born dam constructor James Barrett went on a murderous rampage.

After walking back to the camp from drinking heavily at the dam site near Seven Rivers, Barrett—who had just recovered from "an attack of fever"—went on the search for more whiskey. Co-worker Dan Sullivan refused Barrett's request, but his tent mate, James Barnes, supplied Barrett with another tin cup full of libation. After walking away with his drink, the men thought Barrett was satisfied and returned to sleep.

For reasons he was unable to explain later, Barrett returned to the men's tent, this time armed with a double-barreled shotgun. Barrett asked Barnes to come to the door of the tent, raised the gun and fired point blank at his victim, who died instantly. After witnessing Barnes's death, Sullivan ran to the door to prevent being cut down in the same manner.

After his crime, Barrett found the watchman, Jake Schwab, and demanded to know where the tent of James Deveraux and Jack Holohan was located. The watchman hesitated but felt threatened by the shotgun being pointed at his face. Reluctantly, the man complied and held a lantern as Barrett attempted to wake the men.

Impatient with the slow reactions of the men, Barrett shot Holohan below the collarbone. The gravely wounded man rose to his knees, groaned once and died. Barrett was reported to have said, "I got the right man, and I'm glad of it." With his dirty work complete, Barrett returned to his own tent, told his partner he had just killed two men and disappeared into the night.

A posse composed of Sheriff Dave Kemp, Deputy Sheriff James "Les" Dow, W.W. Bush, William L. Mulhoon, William Stone and George Duncan found Barrett by the Pecos River, and he surrendered without incident. To prevent Barrett from falling victim to the angry lynch mob awaiting him in Eddy, twelve armed men guarded the prisoner until his trial in Lincoln County.

James Barrett was the only person legally hanged in Eddy County. Riding on top of his own coffin in a wagon, Barrett made the trip to the gallows, which were conveniently located near the town cemetery. Before he was put to death, Barrett asked Sheriff Dave Kemp to remove his boots because his father had told him he would die with his boots on, and he wanted to prove him wrong. Kemp complied with the convict's request.

During a long, impassioned speech to the nearly one thousand onlookers who had come with their picnic baskets in tow, Barrett seemed to be in denial of the fact that he had actually committed a punishable crime—pleading self-defense to the end:

> *I am here because I am honest. I killed Jack Holohan because he would have killed me. But just because I killed Jack, you all say, "Kill him! Kill him!" I am not a bad man. I want no notoriety. I have been a rascal in my life. Now I'm going from you. Gentlemen, it is only a few moments before life will leave my body, but I tell you now that I am a man and will die like a man. Goodbye. I am not afraid of this thing (the black hood). Let 'er go!*

Part I: Outlaw Days

Very little physical evidence is left of one of the most violent towns in New Mexico. In fact, even the cemetery has been moved. But some say a few of the former residents are not aware that their final resting place is now twenty-plus miles north in the Twin Oaks Cemetery on the outskirts of Artesia, New Mexico. Tales have been told of a cowboy who rides his horse through the walls at the processing buildings of the Balzano Vineyard and Pumpkin Patch, a little girl who skips happily among the grapevines and a house that is used as a dare for those brave enough to spend time within its walls.

Wrapped in tragedy, mystery and legend, Seven Rivers will continue to endure as long as there is someone to remember it.

3
Bonnie and Clyde Take a Hostage

The Great Depression of the 1930s was possibly one of the harshest eras in American history. Desperation spread across the country as jobs and money became increasingly scarce. It was because of these hardships that a few opportunists began their reign of terror in the United States. Banks, in their attempts to survive, had become ruthless as well, foreclosing on properties at a whim and without much notice, if any. As the criminals began to target the banks, they earned the respect of those who had been victimized by the institutions, and sometimes not so secretly, their actions were praised by the stricken population.

Although the big names like Al Capone, John Dillinger and Lester Gillis, otherwise known as Baby Face Nelson, captured attention in the big cities, it was the antics of a pair of star-crossed lovers, Bonnie Elizabeth Parker and Clyde Champion Barrow, who made crime look romantic. Americans were already captivated by their outlaws—Jesse James, Billy the Kid, Butch Cassidy and many more Old West desperadoes—but the couple added fuel to that fascination.

Much has been written about the duo that spread their terror along quiet rural roads that were usually only protected by one or two members of law enforcement. They made a stop in the small town of Carlsbad, New Mexico, in August 1932, although not too many people are aware of the story.

If Bonnie and Clyde thought they could slip into the one-horse town unnoticed in their flashy Ford V-8 coupe, they were sadly mistaken. It was said that Barrow was so impressed by the V-8 that he wrote a letter

Part I: Outlaw Days

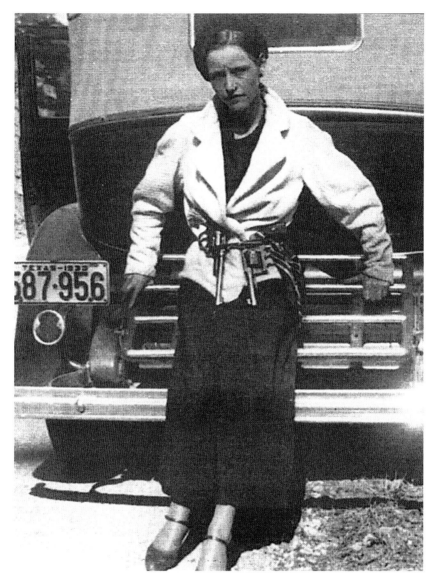

Bonnie Parker and Clyde Barrow captured the hearts of the American public with their lawless actions. *Courtesy of Southeastern New Mexico Historical Society.*

of thanks to Henry Ford, although the Ford Corporation denies the letter's existence.

Unknown to the outlaws, New Mexico had just initiated a campaign against auto theft, warning local authorities to be on the lookout for out-of-state plates.

Bonnie Parker's aunt Nellie Stamps, who was also known locally by the name Millie, lived on what was then the outskirts of town on a small farm and vegetable stand. If the structure had not been demolished in 2006, the home would have been sitting in the heart of the town today at 522 North Sixth Street, which is now a Little League practice field.

Mrs. Dorsie M. (Melvin) Stamps, reportedly unaware of her niece's outlaw antics, had not seen Bonnie for ten years. She later stated she got an uneasy feeling when the tired trio appeared at her door asking to stay. Stamps also went on to say that as the four days passed she felt threatened and had no choice in the matter.

Bonnie introduced Clyde Barrow as her husband, James White, and their companion Ray Hamilton as Jack Smith. Unbeknownst to Nellie, the people in her home had freshly come from Stringtown, Oklahoma, where they killed a deputy—their second victim—seriously wounded another and robbed a jewelry store of its money, "spare" rings and loose diamonds.

Earlier in the day, when they arrived in Carlsbad, the trio had stopped at the People's Mercantile on Canyon Street, where they casually bought a few groceries and appeared to the store clerk, Raymond Lewis, as "normal, everyday sort of people." Lewis did take special notice of the petite woman in the blue dress who asked directions to the Stamps household, mentioning a visit to her aunt. It was not until later events that the clerk became aware of who his customers really were.

Several renditions of the following story have been published in the local newspapers both at the time and more recently.

On Sunday morning, August 13, 1932, Ray Hamilton went into Carlsbad to purchase some ice to make ice cream. While in town, the car garnered the attention of Deputy Sheriff Joe Johns, who had run the plates the day before and knew it matched one reported stolen from a Texas residence. Curious of who had the shiny V-8, the deputy took it upon himself to investigate and followed Hamilton back to the Stamps farm.

Johns, known to his community as a jovial sort who liked to whistle, decided to get a closer look at the car. When he did, one report states that three people burst out of the house with guns drawn, forcing the lawman into the vehicle as their prisoner, wedged between driver Clyde and passenger Ray Hamilton, who had Bonnie perched on his lap and a weapon jammed in the deputy's side, to securely prevent Johns from escaping the moving vehicle.

Another version, and the most credible one, is the story according to a report by Joe Johns himself.

Part I: Outlaw Days

During her niece's stay, Nellie Stamps became more and more nervous of the intentions of her houseguests and began to suspect their true identities, especially after Bonnie had asked her aunt to wash some bloodied clothing.

The closest neighbor, Bill Cobb, who grew cantaloupes on the five acres he leased from the Stamps family, noticed the strangers as well and became enraged when the men started using his melons as shooting targets and started over to stop the duo when his irrigation motor quit, luckily distracting him from the task. Stamps would later confide in Cobb, showing him the bloody clothing, the large packs of money and diamonds she had found under the mattress. The pair knew something was wrong and devised a plan to contact the authorities without bringing attention to Nellie.

Under the pretense of visiting Cobb, Nellie Stamps was able to leave the house, which had become an outlaw haven, to contact Deputy Sheriff Joe Johns to investigate. When he arrived at the farm, alone, at Nellie's request, it was Bonnie Parker who answered the door. When asked who the car belonged to, she sweetly replied, "to a couple of boys staying with them, and they were getting dressed."

As Bonnie turned into the house, Johns took a closer look into the locked car and attempted to open the trunk, where several weapons were stored.

It was then that Clyde Barrow and Ray Hamilton, armed with Browning automatic rifles and shotguns, surrounded Johns while strongly suggesting he turn over his gun belt and get into the vehicle with them. Reportedly, Hamilton got jumpy while relieving the officer of his handgun and discharged his shotgun, which came dangerously close to killing the deputy—fortunately, Johns' hat was the only casualty.

Clyde's favorite weapon of choice was the Browning automatic rifle, which used 30/06 shells and shot twenty rounds every two and a half seconds. National Guard armories held the most caches of these rifles and were targets of the Barrow Gang, even though most National Guard units at this time were on university campuses.

The Stamps family ran a vegetable stand in front of their residence, and several customers were present to witness

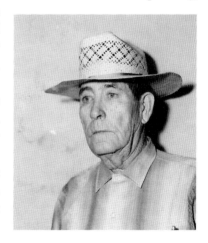

Happy-go-lucky deputy sheriff Joe Johns was taken for the ride of his life by America's outlaw sweethearts, Bonnie and Clyde. *Courtesy of Southeastern New Mexico Historical Society.*

the abduction. Johns wrote that Bonnie's aunt begged the trio to not hurt him, going as far as getting down on her knees to make her point. This show did not change the outlaws' minds in the least. Bill Cobb later stated that Nellie Stamps fainted dead away when she realized her niece had kidnapped the deputy.

Originally wanting to head to El Paso, Texas, so they could blend in easier in a larger town, the unlikely group headed away from Carlsbad south on the El Paso Highway—which is known as the National Parks Highway today—and had gone about four miles when Johns convinced them to seek a more isolated route. The sheriff deputy was confident that the Texas state troopers would have a roadblock already set up outside of El Paso, and he knew he would be caught in the crossfire of certain gun battle.

Retracing their tracks, the travelers took Highway 285 east, back through the southern part of Carlsbad toward Pecos, Texas, and followed a rough ninety-mile-long dirt pipeline road at Johns' urging. It was during this part of the journey that Bonnie was trying to convince Clyde to go back to Carlsbad and "kill the old hen" for turning them in to law enforcement. Johns was able to persuade them that it was purely an accident that he had come by the farm that day and Bonnie's aunt had nothing to do with it.

Johns recalled that Clyde was driving extremely fast for the type of road they were on, and they were forced to stop and change a flat. The remoteness worried the deputy, who thought this spot to be a perfect place to kill him and go on their way, but the trio had other plans. Johns would say later that the outlaws were good to him but would break into a strange slang to communicate so he wouldn't know what they were talking about.

Used as a navigator since he was familiar with the lay of the land, Johns guided them down farm roads to avoid the roadblocks set up by local law enforcement. Near San Antonio, Texas, they were pursued by a pair of motorcycle policemen who eventually lost them. Bonnie asked the lawman how the criminal life felt. "You've had a few hours of it now. We get 365 days of it every year."

The lawman's recollection of Bonnie Parker was that she was the mean one of the three, cussed like a sailor and was responsible for putting the fatal bullet into a wounded state trooper. After one of a few flats they experienced during this ordeal, two men, a Mr. Hatfield and a Mr. Beeman, called out to them and asked if they needed help while walking toward certain death. Clyde told them no, but Bonnie wanted to kill them. Clyde talked her out of it, stating that if they came closer, they would. Luckily for the two men, they stayed where they were and lived to see another day.

Part I: Outlaw Days

It was also outside San Antonio where events took a positive turn for Johns. Clyde asked the deputy if he had any money to get home. "You know it'll take a couple of bucks, and you'll want to have yourself a good time in San Antonio." Johns assured his captor that he had about $45 and really wasn't looking for a good time, he just wanted to get home. Barrow responded, "Sheriff, you've caused us a hell of a lot of trouble, but we like you, and we're going to let you go. Tell your people that we ain't a bunch of nutty killers. Just down home people tryin' to get through this damned Depression with a few bones."

Those were probably the best words Joe Johns had ever heard. He asked if he could keep his pistols if they kept the bullets, but he was refused. But he did get his Stetson and the keys to the car he left behind in Carlsbad. After shaking hands with the stunned deputy, Bonnie Parker, Clyde Barrow and Raymond Hamilton drove out of his life and into infamy.

Six hundred miles from home, Joe Johns collected his wits and, "looking like a tramp," went to two houses along the road before he was let in at the Walker Ranch to call the San Antonio Sheriff's Office. During his bus trip to San Antonio, Johns read his own obituary—a headless body found on the side of the road in Texas had been incorrectly identified as Johns.

His adventures were not over with quite yet. While being driven home to Carlsbad by a San Antonio relative, the car they were riding in skidded into a ditch and landed on its side but was soon righted enough for them to continue their journey to Odessa, Texas, where they were met by Carlsbad police officers to be taken the rest of the way home.

A spur-of-the-minute visit by a trio of famous outlaws would put Carlsbad, New Mexico, in the spotlight for a few fleeting moments, but the adventure would always remain with Joe Johns. A hero's welcome awaited Johns upon his return to Carlsbad, where he would go on to serve four years as county treasurer, four years as county assessor and time as chief of police as well.

Although the outlaw pair made big news and were fourth and fifth on the FBI's Most Wanted List, their largest heist was only $4,000, with most of their robberies ranging more in the $10 to $20 range.

Two years later, on May 23, 1934, Bonnie Parker and Clyde Barrow's crime spree would be complete, as they were shot to death by a large group of police officers south of Shreveport, Louisiana, after being betrayed by a former gang member, Henry Methvin. Raymond Hamilton had been captured a month before and was in prison when the ambush occurred. He was later executed by electric chair in Huntsville, Texas, on May 10, 1935. His last words were "Well, goodbye all."

When Nellie Stamps learned of her niece's death, she was known to have said, "I'm glad she's dead, but I'm sorry she had to do in the way she did, without repenting, because she surely is in hell."

Mrs. Stamps was now able to stop living in fear Bonnie would return to kill her for turning her into the law. The Stamps home was unfortunately torn down by the City of Carlsbad in 2006.

Johns continued his work in law enforcement and as a leading civic figure and well-loved citizen of Carlsbad until his death in 1970. Deputy Johns' gravestone reads, "Joe Johns, an honest politician."

Part II

Campfire Tales

4
Murders on the White Sands

The "pure as the driven snow" color that permeates White Sands can be deceiving. Though they look innocent due to their sandy white hue, they are in fact drenched in the blood of several brutal murders. One of the first murders (or rather one of the first that history has recorded) to take place on the White Sands was that of George Nesmith and his wife and daughter. The couple ran the Old Mill in Ruidoso and, like everyone in the area, were reputed to be friends of Billy the Kid. Ironically, Billy inadvertently had a hand in the family's deaths. As it turned out, Billy was stealing cattle from John Chisum and then selling them to Pat Coughlin, Cattle King of Tularosa and George Nesmith's employer. When the couple later informed on Coughlin to cowboy detective Charles Siringo, they were called to Mesilla to testify against Coughlin regarding this matter.

Before setting out on their journey, Mrs. Nesmith said, "I'm afraid to cross the White Sands. So many terrible things have happened there."[1] On August 17, 1882, the family was murdered while crossing the White Sands by two men, Maximo Apodaca and Rupert Lara, paid by Coughlin. Three weeks later, authorities found the highly decomposed bodies. The two killers were found four years later in Mexico, the coat and shawl of Mrs. Nesmith still in their possession.

Apodaca testified that Coughlin had paid him and his accomplice to kill the family. Lara shot the mother and father, and when Apodaca refused to kill the girl, Lara said he would kill him if he didn't do it. Apodaca was sentenced to life in prison, but his accomplice was hanged. However,

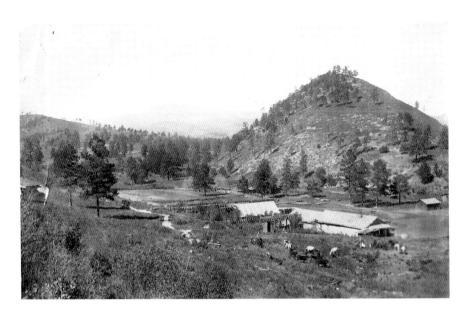

This is the "Old Mill" in Ruidoso operated by the George Nesmith family, murdered on the White Sands in 1882. *HSSNM, #1300.*

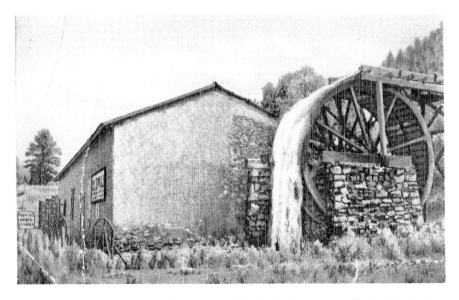

A postcard of the "Old Mill" in Ruidoso, New Mexico, in later years, well after the deaths of the Nesmiths. *HSSNM, #960.*

Apodaca, haunted by the screams of the young girl's ghost, committed suicide in his jail cell shortly after being sentenced.[2]

The next noteworthy recorded death on the sands was that of Walter Good, perhaps not coincidentally an enemy of Oliver Lee. Good had been dead on the White Sands for only two weeks, but all that was found of him were the remains of his clothes and his skeleton. The coyotes had picked him clean. Before the discovery of his corpse, people speculated his body was hidden somewhere on the property of Emma Altman's ranch, possibly under her floorboards. When her house was torched, Lee and Altman claimed the other side perpetrated the act, while Good's supporters claimed Lee did it to conceal "the evidence." The death was mysterious, as Good was found with his own revolver at his side. In his temple were two bullets, but his revolver was not missing two bullets.

It was over this murder and its trial, in which Oliver Lee was accused, that he and the opposing lawyer Colonel Albert J. Fountain first met. As there was no substantial evidence, the court proceedings never got far, but it was the start of a legendary feud between Lee and Fountain.

THE HAUNTING OF ALBERT AND HENRY FOUNTAIN'S KILLERS

The feud between Colonel Fountain and Oliver Lee began in 1888, and C.L. Sonnichsen wrote in *Tularosa* that it "kept the country in an uproar for years and sowed many seeds that bear fruit to this day." Sonnichsen's day would have been the 1960s, and that being said, the Fountain murder and Oliver Lee are still sore subjects some fifty years after that.

Another major player in this Dona Ana County feud was Albert B. Fall, leader of the Democratic Party, which naturally made him public enemy number one for Fountain, leader of the Republican Party. Fall and Fountain first faced each other in the courtroom in May 1890, and it is surprising that it took six years before one tried to kill the other. Things kicked into high gear when Fountain secured indictments for seventeen men accused of cattle rustling from the New Mexico Stock Association. Among them were Bill McNew, Jim Gilliland and Oliver Lee, a friend of Fall's.

The night before Fountain left to deliver the indictments, he listened thoughtfully to his daughter Maggie playing the piano. There he expressed to her his fears that his life was in danger, and if anything happened to him

she would know who had done it. Maggie then suggested that he should take with him eight-year-old Henry, her logic being that no one would dare harm a little boy. At first, Fountain refused, but he eventually came around to the idea, so long as Henry was home in time from school to go with him. It was a fateful decision that cost Henry his life. Had he not gotten home in time to ride off with his father, he might have lived to adulthood.

Bad luck plagued their voyage from the start. On the first night of the trip they camped out at San Agustin Pass, and someone, or perhaps even something, frightened off their horses. Fountain knew they would return home and simply waited for them to do so, knowing full well that when they did his eldest son, Albert Jr., would return them to him. Albert showed up with the horses a full day later. Perhaps having a premonition, Fountain urged Albert Jr. to take Henry back with him, but both sons protested too much and won their father over. Henry would stay on the fateful trip.

The duo arrived safely in Lincoln, and Fountain delivered the indictments in the very courthouse from which Billy the Kid had escaped some fifteen years earlier. While there, someone handed Fountain a note stating, "If you drop this we will be your friends. If you go on with it you will never reach home alive."

Fountain delivered the indictments anyway and then left Lincoln on January 30 and stayed the night at Blazer's Mill, another infamous spot stained with the blood of the Lincoln County War. Nearly twenty years earlier, Billy the Kid and his gang shot it out there with Buckshot Roberts, killing Roberts and Dick Brewer. Local legend stated the two enemies were buried in the same grave, though this is unlikely. As it turned out, Dr. Blazer was playing host to another dead man that night in 1896. Blazer knew the score from local gossip and encouraged Fountain to take along some of Blazer's Apache friends as guards, but Fountain refused and set off on his own with Henry across the White Sands.

Three days later, Fountain's wife and eldest son went out looking for the two. Only an empty buckboard was found—minus the bodies—and later, as the search intensified, a puddle of blood was discovered. Around the buckboard were the tracks of three horsemen, and it appeared that the tracks led straight to Oliver Lee's Dog Canyon Ranch—though eventually cattle from this same ranch were herded across these tracks before anything official could be deduced. As such, the three primary suspects in this mystery became Lee, Gilliland and McNew.

Much like Billy the Kid, Albert Fountain and his son popped up numerous places after their deaths, be it their living selves or just their dead bodies.

Part II: Campfire Tales

Leon Metz wrote in his book *Pat Garrett: The Story of a Western Lawman*, "Their bodies supposedly turned up in a half-dozen places in the Southwest."[3] Various stories said the bodies were thrown into a steep canyon in the San Andres or buried in a corral and a stampede of horses was used to trample down the ground, with many other variants.

One story alleged that Oliver Lee burned the bodies with mesquite roots inside a steam boiler firebox at Wildy Well. This story was told to Leon Metz by Mary Ellis Wright, a relative of the Gilliland family, who claimed an unnamed member of the family hauled three wagonloads of mesquite root to the spot to assist in the burning.[4]

A more gruesome story says Albert and Henry were buried in a grave that proved a little too shallow at Lee's Dog Canyon Ranch. Jim Gilliland's younger sister Lucy claimed that one morning she found the hogs digging up young Henry's remains. She fainted at the sight of the hogs tearing apart the dead body, and soon some of the ranch hands retrieved the corpse and buried it in another spot. Lucy reportedly knew of the killings. Her brother Jim was threatened by Bill McNew at a saloon once. McNew told him that he better keep quiet, or "it wouldn't be like cutting the Fountain kid's throat."[5]

The most bizarre story concerning one of the murderers, Bill McNew, was told to Leon Metz by a mysterious source who preferred to remain anonymous. The story went that in 1937 McNew suffered a stroke and quit breathing. When McNew revived, he told a horrific tale that he had gone to

The mysterious White Sands of Alamogordo, as photographed by Paul Larkham. *HSSNM, Larkham Album #3.*

A trail through the White Sands, probably not unlike the ones traveled by Albert Fountain and his son Henry in their buckboard wagon. *HSSNM, Larkham Album #3.*

To this day, many people believe the bodies of the Fountains can be found somewhere buried under the sand dunes. *HSSNM, Larkham Album #3.*

hell and stood in molten lava up to his knees. Sometime later that year, the lower parts of his legs blistered and the skin peeled off as though they had been badly burned. Then McNew had another stroke and died.

Of the three killers, it was Gilliland that would often talk. He once pointed out a grave (marked with a rock)[6] north of the Lava Gap near an

Part II: Campfire Tales

> ### Billy the Kid Avenges the Fountains
>
> *Some of the most far-flung tall tales of Billy the Kid come from* The Young Pioneer When Captain Tom Was a Boy, *a book passed off as nonfiction, but it is entirely fictitious. It recites a penny-dreadful rendition of the Kid's history, with he and Pat even having a scuffle in Tombstone, Arizona. The most delightful story in this tome concerns Billy the Kid's involvement in the disappearance of Albert Fountain (which occurred fifteen years after the Kid was dead, mind you). In this rendition, Billy warns Fountain not to venture into the White Sands, and Fountain and his son are killed and buried in the sands by the Tate Gang. Billy witnesses the event, and as such becomes "The Mounted Ghost of Crawling White Sands," who cannot leave the area until he avenges Fountain by killing all of the gang's members. Billy stays at a mythical Indian oasis on the sands and wears a white robe while riding a white horse to extract his vengeance.*

arroyo in the San Andres to his friend Butler Burris, saying, "Son, that grave holds a lot of secrets."[7] Gilliland eventually told Burris that was the grave of the Fountains and they had been dug up from another spot and moved there, lending credence to the reports of the hogs rooting up the graves by Lucy Gilliland.

The killing of Albert Fountain didn't bother Gilliland at all, who would reportedly laugh about the killing when recounting it to Burris. "That old son of a bitch [Fountain] jumped out of that wagon like a big toad. He hopped directly between the two horse riggings and was dead when we reached him."[8]

When talk turned to young Henry, Gilliland became morose and somber, clearly haunted by the killing. By Gilliland's own account, the killers drew

One last look at the desolate yet beautiful White Sands, where many men have met their ends. *HSSNM, Larkham Album #3.*

straws (specifically grass stems) to determine who had to kill the boy. "One account said McNew drew the short straw; another that Carr was with the party and he drew the short straw; and yet another was that Lee drew it and paid the others to do his job," wrote A.M. Gibson in *The Life and Death of Colonel Albert Jennings Fountain.* Oddly, rather than shoot the boy, Gilliland said he slit his throat.

When Gilliland was on his deathbed, he gave Burris a Masonic pin that belonged to Albert Fountain and asked that Burris return it to Albert Fountain Jr., who later said it was indeed his father's pin after Gilliland's death on August 8, 1946. When Burris led an expedition to the grave site, several holes were dug, but mysteriously, no bodies were found. It was the last attempt to find the graves of the Fountains in recent history—or at least recent recorded history.

5
GHOSTS OF THE LINCOLN COUNTY COURTHOUSE

In a place stained with as much blood as the Lincoln County Courthouse, it seems only natural it would have its fair share of hauntings. The most famous killings there occurred when Billy the Kid made his famous jailbreak on May 13, 1881, killing first his guard J.W. Bell and then deputy "Pecos" Bob Olinger with his own shotgun. These were not the first deaths to occur there, however. The first death to happen at the courthouse occurred during its construction in 1874, when a man fell to his death from the roof. In "Ghosts of Billy the Kid's Outlaw Band to Appear Again," Federal Writer's Project reporter Georgia B. Redfield wrote:

> *It is not at all surprising that some of the more superstitious natives of Lincoln, New Mexico believe that "El espiritu malign" (spirits of the devil) meaning the five men of Billy the Kid's outlaw band, who were killed as they ran from the blazing building* [the McSween Home], *return on dark nights to the scene of the final battle of the Lincoln County War of 1877–1881.…Still carrying guns, it is believed they stalk the narrow streets, around El Torreon in the spooky old town, near the old courthouse at Lincoln, now a state monument and popular tourist attraction.*

Of course, it was after the famous killings of Bell and Olinger that ghosts began to haunt the imposing structure on a regular basis. An old article from the 1940s states, "Since that day the Lincoln County Courthouse was said to have been haunted—haunted by the ghosts of its many victims."[9] "At night

Left: A side view of the Lincoln County courthouse prior to a much needed restoration. *HSSNM, #2276A.*

Below: George Coe, pal of Billy the Kid and famous "frontier fighter," descends the steps of the old Lincoln County Courthouse. *HSSNM, #5453B.*

queer ghostly noises were heard emanating from the big two-story building. The natives wouldn't go near the place because it was infested with ghosts. Billiard balls were heard clicking together, yet there were no players after the sun went down behind the mountains."[10]

Reportedly, the billiard balls were racked every day, but come nightfall, the noises would begin again. In the morning, the balls were scattered all over the pool tables. The villagers began calling the specters the Ghosts of La Casa Corte. A few of the townsmen decided to go inside and investigate, and among their numbers were Billy Burt, whose horse Billy the Kid borrowed during his famous escape. The men entered the old courthouse at the bewitching hour, armed to the teeth with revolvers. For a long while, they tensely waited together in the silence, and after a while, all stretched out on the floor together. Finally, the sound of clicking balls began emanating from the next room. All the men held their breath, anticipating their next move, when suddenly "out of the darkness, two burning, glaring eyes appeared above them." The men immediately took aim at the deadly specter and fired away. A thud hit the floor in the darkness, one of the men produced a light and the ghost turned out to be a stray cat. But, the billiard balls began clicking again in the next room; perhaps the cat wasn't the culprit after all. The men tiptoed as quietly as they could into the next room, only to discover a whole room of cats playing with the balls and scampering across the tables. And so the legend of the ghosts of La Casa Corte was put to rest.

6

OLD RUIDOSO

John Chisum's Ghost Steer

Many a tall tale has emerged in one way or another from the Lincoln County War. Most of these tales involved Billy the Kid in one way or another. One such example is an exaggerated version of Billy's escape from the courthouse in Lincoln, which goes that the Kid was so heavily armed during his escape that he left two of his pistols and a cartridge belt in the fork of an old oak tree out in the forest. Billy never returned for them, and to this day, supposedly, an old oak tree exists out in the Capitan Mountains that has grown with his guns still in its heart.

A lesser related tale, probably because it doesn't contain Billy the Kid, to spring from persons involved in the war is the story of Old Ruidoso. *Ruidoso*, which means "noisy" in Spanish, was a Texas Longhorn steer that belonged to the legendary cattle baron John Chisum at his South Springs River Ranch near present-day Roswell. Old Ruidoso was what was known as a "decoy" steer in that, due to his immense size, he was used by cattle drivers to lead the herd on long drives. To show the steer's "leadership status," a long rail was burned into its hide to differentiate it from the other large steers.

However, being a decoy steer had an additional meaning, being that he was also a decoy for rustlers. How it worked was the Chisum brothers put a hidden rail brand on the steer's inside flank. In essence, this made it easier for Chisum to catch a rustler from a legal standpoint, as the rustler probably didn't see the brand in the first place, a rather dishonest trick if there ever was one. One of the first to come across Old Ruidoso was one of Billy the Kid's friends/enemies, Jesse Evans, who was far too wise in the ways

of rustling to abscond with Ruidoso. Instead, Evans branded him with a question mark. Other would-be rustlers caught on and added their own brands to show just what they thought of the dirty trick. Reportedly, within a few weeks, Old Ruidoso was covered in brands, some of which were in the shapes of snakes and scorpions.

Old Ruidoso's most notorious brand came from "Pecos" Bob Olinger, who was riding along the Pecos River when he spied Old Ruidoso near its banks. Olinger roped Old Ruidoso and then branded him with a skull and crossbones and placed a curse on him. As he did this, the then-unnamed steer let out a bellow unlike any other, and Olinger dubbed him Ruidoso and said, "Your appearance in the roundups from Horsehead Crossing to the Bosque Grande on the Pecos shall be a curse, and I wish you could live a hundred years. But when you are dead and gone, I hope that terrible bellow of yours will haunt the people. I know that this curse I am bestowing on you will contribute to the population of every boot-hill cemetery along the Pecos."[11] Some tellers of this tall tale even like to say Olinger's "curse" was what helped to start the whole Lincoln County War, for it was shortly after Olinger branded Old Ruidoso that the war broke out on the range.

But was Bob Olinger really the one who branded Old Ruidoso, or was Olinger merely the villain chosen by campfire storytellers? Olinger, it should be noted, aside from being Billy the Kid's tormenter in jail, was also on the side of the "bad guys" during the Lincoln County War. So vile was Olinger, reportedly his own mother was glad when he finally bit the dust. Olinger, being on the opposite side of John Chisum and his men, could have branded Old Ruidoso out of spite, but there's still no real way of proving it.

Either way, the curse of Old Ruidoso would come back to haunt Olinger in the form of outlaw Billy the Kid. When Billy was being held at the Lincoln County Courthouse after being sentenced to hang for cattle rustling, Olinger was the Kid's constant tormenter. It should also be noted that Olinger had earlier killed the Kid's good friend John Jones in a shootout. The Kid got his revenge after he shot and killed guard J.W. Bell while Olinger was out. Billy picked up Olinger's own buckshot-loaded shotgun and waited for Olinger from the second-story window. "Hello, Bob," the Kid said casually when Olinger came into range. Olinger looked up and got a face full of buckshot and died, after which Billy rode out of town.

While Old Ruidoso's link to Olinger's death is a tenuous one, Ruidoso was said to be directly responsible for the death of another famed New Mexico gunfighter, Clay Allison, in 1887. The story goes that Allison was in his wagon, driven by a team of pack mules, when Old Ruidoso spooked them.

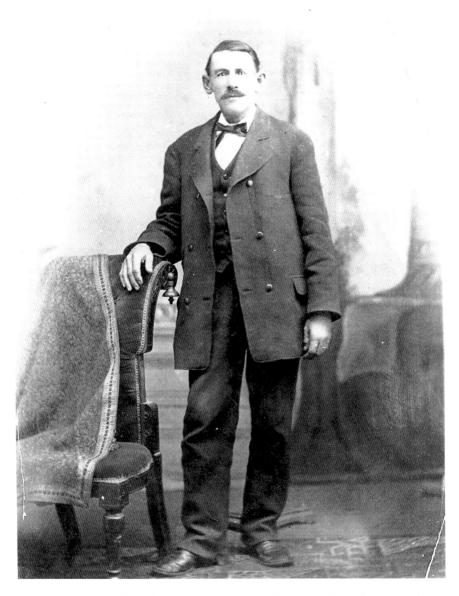

The legendary John Chisum in a standing photo portrait. In 1970, John Wayne starred as the titular character in *Chisum*. *HSSNM, #604D.*

Part II: Campfire Tales

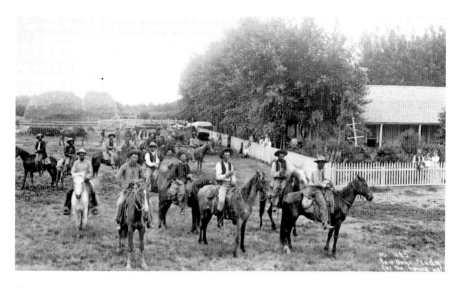

The many cowboys and ranch hands (among them Frank Chisum on the white horse) at Chisum's South Spring River Ranch, c.1881. *HSSNM, #588.*

"There's that damned hoodoo steer, I'm going to kill him!"[12] he was said to shout. But that's when the mules got spooked and the wagon wheel suddenly struck a salt bump. Allison was thrown from his wagon, broke his neck and died soon thereafter, believing it to have been the curse of the devil steer.

A year before Allison's death, Old Ruidoso wandered into a cattle roundup on the West Mora arroyo. When the cursed steer was spotted, one cowpoke said to another, "I expect hell will pop. I see the hoodoo steer over there."[13] And within twenty minutes, two of the cowboys had gotten into an argument, and one shot the other.

Among other alleged deaths at the hooves of Old Ruidoso was one Zack Light, who informed the residents of Seven Rivers that he had just seen the cursed steer on the trail but wasn't worried, as he believed the teachings of Hugh Leeper, the Sanctified Texan (also the same pastor who performed Billy the Kid's funeral). Leeper was a popular Texas preacher who preached on predestination, or that a man's time wouldn't come until his time had come, so to speak. That night, Light's time came, and he was killed in a poker game. Some even attest that Pastor Leeper himself came under Old Ruidoso's bad luck. So the story goes, Pat Garrett's deputy Barney Mason was losing everything he had in a poker game one night. As the boys teased Mason that he must be under the curse of Old Ruidoso, Mason put up his coat as collateral in the game, as he had no more money to wager. When

Mason handed the coat to a bystander, the nosy man went to browsing through Mason's pockets. Inside he found wanted papers for a man matching Pastor Leeper's exact description. The man, a friend of Leeper's, went to warn the outlaw preacher he had been found out, and the Sanctified Texan was seen no more in southeastern New Mexico.

Another tale, set just outside of Roswell at a place called Pilky Flats, says Ruidoso was spotted grazing with old man Pilky's milk cows. The next day, the whole Pilky clan was found dead, with doctors claiming it was due to poisoned alkali milk. This was just the beginning of Old Ruidoso's reign of terror, however. Soon his bad luck would result in the relocation of an entire Texas town.

In 1888, Old Ruidoso was deemed public property, as John Chisum had passed away long ago, and a law had been passed that all defaced branded cattle stock be deemed public property. As such, several cattlemen got together and decided that Ruidoso should be dealt with once and for all and be taken to Amarillo for the slaughter. As no trail bosses wanted to take part in a cattle drive that Ruidoso was a part of, a popular trail boss named Colonel Jack Potter agreed to drive Ruidoso to his final resting place.[14] In the story, Potter rides up beside Ruidoso on the trail drive and says to him, "Ruidoso, you old outlaw devil, you might think I'm going to give you a cussin', but I ain't. But I am goin' to give you a good talkin' to. You gotta remember you've blazed a trail of bad luck a long way west of the Pecos already. But now, at your age, you're just a 'has been!'"

Roswell historian Clarence Siringo Adams transcribed the entire conversation between Potter and Ruidoso in his book *For Old Time's Sake*:

> It looks to me like if you ever come back to your old stomping grounds it may be in a can marked "Corned beef." Well, old son, I'm gonna see to it that your old hide will be put on exhibit in the Historical Museum at Santa Fe to show posterity them ugly brands on your mangy old hide. Then I'll put a sign up above tellin' the world about the part you took in the bloody range war. You caused it—you old mosshorn devil! But now, you old jinx, you're going to perform once more—just one more time! I don't care how old and ragged you are—you still got instinct. You're goin' to be my lead steer for a drive and I'll expect you to pilot this herd clean through to Amarillo!

In Potter's mind, the drive to Amarillo had been one of the straightest in history, but the drovers had other stories. To them, the drive was filled with bad luck, and at night, they would gather around the campfire to talk about

Part II: Campfire Tales

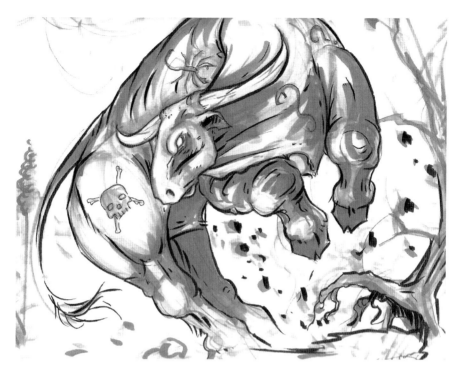

Artist Chris Casey's rendition of a fearsome Old Ruidoso, the ghost steer. *Courtesy of Chris Casey.*

the day's events and ponder shooting Old Ruidoso right between the eyes. It seems the old steer mostly made them nervous. Nothing of any consequence seemed to happen during the drive, and they all reached Amarillo, a relatively new town along the Texas Panhandle, without incident.

They all happily waved adios to Old Ruidoso and his herd, ecstatic to be free from any future bad luck. This truly was to be Old Ruidoso's last drive. Upon arriving by train in Kansas City, Old Ruidoso and the rest of the cattle would be slaughtered. But Old Ruidoso had other plans. When Colonel Potter and his men returned to Fort Sumner after seeing Ruidoso off on the train from Amarillo they got the news. Just ten hours out of Amarillo, the train carrying Old Ruidoso had derailed and wrecked. No one knew why, but several men and cattle were killed. Most of the cattle escaped, and included in those missing was Old Ruidoso. The town of Amarillo was so spooked by the incident that they, too, worried that they had fallen under Ruidoso's curse. So superstitious were they that they even moved the whole town out of the lakebed where it originally stood to its present location today.

With Ruidoso getting the last laugh and staging an extravagant escape back into the wild, one would think that this is where this tall tale ends. But it doesn't. No one knows how or when Ruidoso died, but his ghost soon began haunting the mountains of New Mexico. West of the Pecos, settlers began telling tales of the bloodcurdling bellows of a steer they could hear up in the mountains. They began to say it was Old Ruidoso returned to his old stomping grounds. A man named Vicente Otero, of Fort Sumner, was said to have been the first to see Ruidoso's ghost and as a result had been driven mad because he would get down on all fours and paw and bellow at the ground just like Old Ruidoso did.

Ruidoso would save his grandest appearance for last though, when he was blamed in a roundabout way for New Mexico's most famed unsolved murder: that of Colonel Albert Jennings Fountain. By 1896, Colonel Fountain had become a judge in Mesilla, New Mexico. Fountain had just successfully brought forth indictments against various prominent citizens for assorted infractions of the law, including cattle rustling on the part of Oliver Lee, Jim Gilliland, Billy McNew and Joe Morgan. Fountain had left Mesilla with his eight-year-old-son Henry to go to the trial in Lincoln to prosecute the men in January 1896. After successfully doing so, he loaded up his wagon with young Henry and headed back to home for Mesilla. He was warned by several people that this would be a dangerous time to travel across the White Sands alone. Fountain didn't seem worried and picked up his shotgun, stating, "This will be my protection."

The most interesting warning Fountain received though came from a Mescalero Apache man. Fountain and his son had just spent the night in La Luz and were about to ride out alone through the mysterious White Sands the next morning when the old Apache stopped them to talk. The old man told Fountain that for three nights in a row he had heard Old Ruidoso the ghost steer bellowing away in the mountains. He had heard the bellow near a place called Blazer's Mill, where one of the greatest and bloodiest gunfights in the Lincoln County War had taken place years before. Two men were killed in the fight, Dick Brewer and Buckshot Bill Roberts. The Apache said that only a few nights before there had been a great flash of light over the Mescalero Reservation to the west. In the flash could be seen the silhouettes of the dead Buckshot Roberts, Pecos Bob Olinger and Old Ruidoso himself. Because of this, the Apache said Fountain and his son should not venture out onto the sands alone any farther.

Fountain only laughed at the superstitious old Apache's warning and went on his way. He and his young son were never seen again. To this day no one

Part II: Campfire Tales

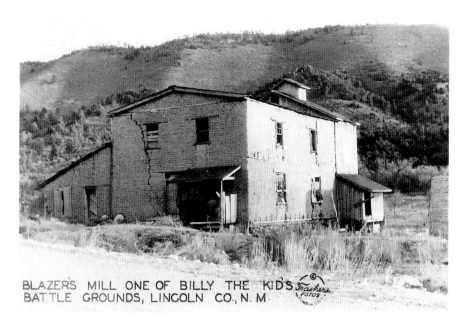

Blazer's Mill, near Mescalero, New Mexico, was one of the last places the Fountains were glimpsed alive in 1896. *HSSNM, #5160.*

knows what happened to them. All that was ever found of Fountain was his buckboard wagon and two puddles of blood. Who, or what, killed them can only be speculated on.

Like any good legend, there are plenty of problems with stories concerning Old Ruidoso. One of the main problems include the dates of certain stories, specifically in relation to John Chisum and Clay Allison. In the story in which Ruidoso is attributed to Allison's death, the accident occurred in Seven Rivers, New Mexico. The historically proper version of Allison's demise has him dying in a wagon accident, but this time in Pecos, Texas, in 1887, and nowhere is it mentioned that his team (this time made up of horses) was spooked by an animal of any kind. Also, John Chisum died in 1884, four years before the eleven-year-old bull became public property in 1888.

Stories of a ghost steer were popular in Wild West stories for pulp magazines for many years. J. Frank Dobie in his book *The Longhorns* writes of a maverick steer branded MURDER along its hide that wandered alone through Pecos County for years, never in the company of other cattle. Dobie notes that sometimes, but not often, a young cow's brand will grow along

with the cow, getting bigger as it gets older. Dobie says that this particular steer was one such example where the letters in M‍urder grew to enormous proportions. Eventually, it died and became a ghost steer—often seen fleetingly at dusk—and was taken to be a bad omen.

Was Old Ruidoso inspired by this fairly common cow tale, or was he the originator himself?

7
THE PETRIFIED MAN OF THE GUADALUPE MOUNTAINS

In 1892, the country had just survived a presidential election that saw incumbent candidate, Benjamin Harrison, win by the Electoral College votes and Grover Cleveland, who had won the popular vote, ultimately lose the election, as well as Sunday school teacher Lizzie Borden arrested for the grizzly double murder of her own parents. Times were not as exciting in Eddy (soon to be Carlsbad), New Mexico, but that was about to change.

A scheme cooked up by a pair of carpenters and residents, E.W. Doll and J.B. Coates—most likely in a Phenix saloon—would cause a sensation for the citizens as curiosity spread through the sleepy town. An eight-foot petrified man (other dimensions were mentioned in different newspaper articles) was resting in the darkness of the Dome Room in McKittrick Cave, which would later play home to hermit Bob Brookshire. The story revealed by the two men stated they were exploring the cave, looking for treasure, when they literally stumbled upon their astounding find.

The newspaper office of the *Eddy County Citizen* was their first stop as they began to spin their fanciful story. Headlines broke on November 25, 1892, in Eddy and across the entire state about the discovery of a well-preserved petrified prehistoric man being found in "Big Cave," now known as Gray's Cave and McKittrick Cave, located eighteen miles west of the town. McKittrick Hill holds twelve caves ranging from fifty feet to twelve miles long, including McKittrick Cave.

A.J. Howe, editor and publisher of the *Eddy County Citizen,* reported on November 26, 1892, that he had accompanied the pair with a group of

Located eight miles west of present-day Carlsbad, McKittrick Cave was a favorite day trip destination for those who sought a little weekend adventure. *Courtesy of Southeastern New Mexico Historical Society.*

This sketch appeared in local newspapers to entice the curious to take a peek. *Courtesy of Southeastern New Mexico Historical Society.*

other curious residents to the cave for recovery of the Petrified Man. What he found was a well-worn figure—it truly was, especially given that the schemers had to literally break off part of the feet of the man to get him into the cave.

An article in the *Albuquerque Morning Democrat* on November 25, 1892, went into much more detail, describing the figure as

> *being five feet ten and a half inches high, well proportioned, has been a fine specimen of manhood. It is difficult to determine whether it was a white man or an Indian. Some indications point to either direction, some evident*

Part II: Campfire Tales

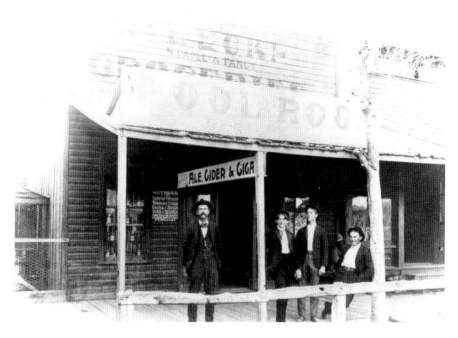

Leck's Grocery Store became a busy spot for those who wanted to see the Petrified Man of the Guadalupes. *Courtesy of Southeastern New Mexico Historical Society.*

of great antiquity, some of modern origin, distinct imprint of sandals or moccasins on the feet, but the hair is cut modern. Indian nose, but no high cheek bones, was found in a large chamber with limestone walls about 500 feet from the entrance to the cave. No other evidence that the cave has been inhabited, at least in modern times. The body had evidently been placed there by other bands after death, as it laid on its back with its hands across its breast and its eyes closed, mouth slightly open, no fragments of clothing or implements were found. The cave is three to five miles long, has over 200 distinct chambers and some wonderful formations of stalactites, stalagmites, petrification of vegetable matter, etc. The question has been raised whether it is another Cardiff Giant scheme, but all who examine believe it a genuine petrification of prehistoric man.

The Petrified Man was brought into town to be put on exhibit—with much fanfare and excitement—on the back of a large wooden freight wagon. Covered by a cloth, the figure was taken to the local grocery store, owned by J.B. Leck, to be put on public display.

Lines to see the oddity stretched around the block, and people were more than willing to pay the one-dollar entry fee to see the ancient man. Everything was going well for the enterprising duo until someone from the railroad office recalled signing for a nine-foot-long, five-hundred-pound box that had been shipped to Doll and Coates a few days prior. With this knowledge, the Petrified Man was examined closer and found to actually be constructed of concrete.

On December 16, 1892, less than a month after its "discovery," the hoax was exposed. The *Santa Fe Daily New Mexican* reported on December 19, 1892, "A wagon backed up to the rear of a building in this city [Eddy] and four loud voiced men quickly transported the late unpleasantness, 'the petrified man,' to the bottom of the wagon and J.B. Coates and a man named Earhart mounted the wagon and drove his majesty off into the land that knew him not. Coates disposed of his house and contents last Saturday and shipped his family to California."

Knowing that the jig was up, Coates did indeed vacate Eddy on the same date as the newspaper article. Doll, a contractor, had already left on December 9 of that same year. A month prior to the discovery, E.W. Doll had been shot and wounded by a Phenix saloon owner, O. Eastinel, who was fined fifty dollars for carrying arms and wounding Doll.

The Petrified Man was a creation of Portland cement by artist Pascal Torrini of Los Angeles, California, who had a successful career in turning out these type of figures. Cardiff Giants were also showing up around the country, in museums and at side shows at this time. The United States had a distinct wonderment for ancient man—real or fake.

Our Petrified Man went on to astound others in different states once it left New Mexico. In March 1893, the figure was owned by Hade Wallings in Tulia, Texas, where he was being billed as the petrified remains of John Younger, kin to the outlaw family—although he was never an outlaw. The story claims that the "body" was identified by one of John's cousins who was positive this was her relative who had to escape a posse by hiding in the Guadalupe Mountains. Other family members point out that John died and was buried in Colorado.

Another claim of identity came from John Ward of Honey Grove, Texas, who declared the body to be of William Conley, a cowboy who had died in a Guadalupe Mountain cave at the hands of Indians. Ward was so positive this was Conley he sent his own cowboys to bury the body.

The Petrified Man was once again sold to a group in Gainesville, Texas, for a tidy sum of $6,000 after it had been examined by "men of integrity"

who declared him to be the genuine article and was heavily toured in the state of Texas.

Many petrified men surfaced between 1892 and 1895 across the United States. Most of them were manufactured by Torrini and others like him who were doing it for the art value. It is not known what ultimate fate awaited the Petrified Man of the Guadalupes, but one can certainly say he was a money maker for those who used him.

It was announced in June 1893 that E.W. Doll and J.B. Coates took in $100 from the good citizens of Eddy, who had laid down their dollars to see the area's biggest hoax. When the duped residents of Eddy heard that the hoax man was going to be displayed at the World's Columbian Exposition in Chicago in 1893, they began an investigation and revealed the true "identity" of the Petrified Man to the world, much to the disgrace of all who had profited from his existence.

Doll and Coates wisely and quickly left Eddy, not to return.

8

Giant Rattler of the Valley of Fires and Other Big Snakes

In what was surely the strangest news to hit southeastern New Mexico since the Roswell UFO Crash of 1947, the *Ruidoso News* reported that a giant rattlesnake had been killed near Carrizozo in July 1960. The monster snake was killed by two Lincoln County men, forty-five-year-old Juan Baca and forty-six-year-old Mike Gonzales. The duo had taken their burros out to graze near the famous Valley of Fires lava beds when they spotted something peculiar in a dried-out pond bed: the ground seemed to be moving up and down.

The following comes straight from the original July 12, 1960 *Roswell Daily Record* article "300-Pound Rattler: World's Largest?":

> *"The ground seemed to be going up and down,"* [Gonzales] *told* [*Ruidoso News* editor Vic Lamb]. *It was the snake breathing.*
>
> *Approaching to within 12 feet, he suddenly stopped, he said, frozen with fright. Gonzales had a Winchester with him and shot four times, missing every time as the snake raised its head five feet off the ground and "growled," rather than hissed.*
>
> *"I was scared," Gonzales said.*
>
> *Baca was some 200 feet away when he opened fire, aiming at the monster's backbone. All eight bullets hit the snake, but none of them penetrated the telephone-pole thickness of the frightful thing…Baca said smoke appeared to come out of the snake's body when the bullets struck home, but said it was probably dust.*

Part II: Campfire Tales

The snake, in its death throes, stirred up a cloud of dust "like a herd of horses," Baca said.

The story caused considerable stir all across the state, with many other news services picking it up on the wire. One may now ask, just why did Vic Lamb and the rest of the press believe the fantastic story? As it turned out, the two ranchers had "proof" in the form of an eighteen-foot-long snakeskin, which they brought with them into town ten days after shooting the snake. The duo claimed that they wanted to bring the snake back whole but couldn't figure out a way to carry it. "It'd be too heavy for a horse," one of them said.

Naturally, within a few days, skeptical articles on the discovery began to be printed, such as "Experts Don't Believe Snake Is So Large," which reported:

Growing skepticism is being voiced about the 18 foot snake reportedly killed near Carrizozo.

Wayne Walker, El Paso curator, offered $100 an inch for any snake over eight feet long, with the view that his money is pretty safe.

Earlier this week Dr. Ivo Poglayen, director of the Rio Grande Park Zoo in Albuquerque, said such a snake as the one reported from Carrizozo would be a real "buzzer."

"About nine feet is the biggest one I ever heard of," Dr. Poglayen said. "I can barely believe 18 feet."

He said some snakes live to about 30 years in age and like all species of animal or reptile life have a maximum size. There is no species of snake in New Mexico that grows to an 18 foot length, he said. Such a size would be extremely large, even for a python.

Another newspaper article reported that perhaps the snakeskin would go on display in the Smithsonian, and another reported the two ranchers had been offered $750 for the skin. Ironically, this same skin eventually proved to be the story's downfall. Through the investigative prowess of Vic Lamb of the *Ruidoso News* and his son, Jim Lamb of the *Albuquerque Journal*, it was found that the snakeskin was actually that of a python. Jim Lamb tracked down an Albuquerque woman, Mrs. W.O. Edington, who claimed that the python skin had belonged to her, and she had thrown it away in a dumpster in Ruidoso, where she owned a cabin. The skin was then picked up by a trash man, who traded it to Baca and Gonzales for ten chickens. The duo later said, "All we hoped to do was make a little money from selling the

skin, and we were misled by a third party into believing it was a genuine rattlesnake skin."[15]

Sometime after this, a humorous follow-up story was written, titled "Tex—The Friendly Rattler":

> *Ervin F. Crockett, whose ranch borders the Mal Pais west of Carrizozo, came into town last week all shook up because "Somebody came out on my ranch and killed 'Ole Tex,' my pet rattlesnake."*
>
> *Sr. Crockett was about the most disturbed cattleman who ever came into the county seat to air a grievance. He said: "I traded a good saddlehorse for Ole Tex a year ago in Texas. I been feedin' him a goat every other day and I had 'im in halter broke and branded with my Rail-D brand. This summer I was goin' to saddle break Ole Tex so's I could ride him to chase goats in the Mal Pais. You should see how easy those big rattlers slide over the rocks and crevices."*
>
> *"Now I want it strictly understood," he said, "Nobody comes out to my ranch and shoots these big snakes, I don't care if they kill the little ones seven or eight feet long, but those 18 footers I got use for as I say."*

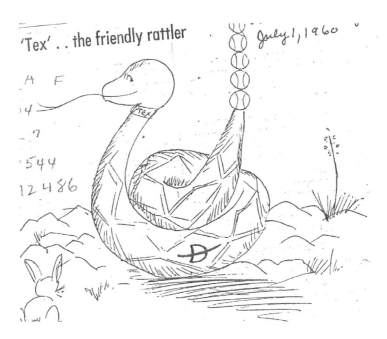

Humorous drawing of "Tex the friendly rattler" that appeared in newspapers once the giant snake was revealed to be a hoax. *Author's collection.*

Part II: Campfire Tales

The prehistoric-looking Valley of Fires State Park, created long ago by an erupting volcano, in Carrizozo, New Mexico. *HSSNM, #6281*.

One account of an adventurer battling oversized rattlesnakes is found in the papers of Roswell optometrist Dr. L.B. Boellner. Dr. Boellner was a recognized horticulturist known for his Kwik-Krop Black Walnut and scented dahlia and lived and practiced in Roswell from 1904 until 1951.

In May 1931, Dr. Boellner went on a hunting trip with a female friend, Annie Lou Moore. Both took .22 rifles to go and hunt rabbits. Had Dr. Boellner known what he was to come face to face with, he would've taken a shotgun. Their hunting excursion was on Six Mile Hill, a vast wasteland west of Roswell full of jagged rocks and dry sinkholes. Upon entering the area, the two bagged several rabbits, but both felt the young rabbits were not anywhere near as plentiful as they should have been in the spring. The two began to wander in the area and split up. Dr. Boellner wished to give one of the larger sinkholes personal explorations, as not many people ever went down in one. He would soon find out why.

This particular sinkhole he described as being fifty feet across. He climbed down inside it and wrote that it was fifty feet at its deepest and eight at its most shallow. It was also outlined with various cracks and crevices, not to mention the bones of many, many rabbits. It didn't take long before Dr.

Dr. L.B. Boellner, famous horticulturist and, in this tale, killer of large fearsome rattlesnakes. *HSSNM #, 2253.*

Boellner saw the first rattler coming at him. The tale is more interesting in his own words:

> *I had only one thing to do, and that was to shoot him without delay. My first shot struck him about three inches back of the head and stunned him.*

Part II: Campfire Tales

> *Just at this time, out came another of equal size with open mouth and tongue out. He too, was coming straight for me and only about two feet behind the first one. I shot the second one about a foot back from the head. Both of these snakes were only crippled. I knew I had to do what I was going to do quickly, so I gave both snakes bullets as fast as I could to stop their approach.*

Boellner continues with the appearance of a third snake, which he shot and apparently blinded, as it struck out with its fangs aimlessly before eventually falling into a cavity in the ground out of sight. With the third snake out of the way, Boellner focused his attention on the other two, which he spent his entire chamber of ammunition on.

At this point, the dead snakes were stopped no less than three feet away from him. By this time, his female friend had come to his aid, and he climbed up out of the chamber. Dr. Boellner gives no precise length for the snakes but said, "All of these rattlers were of huge size; one had 22 rattles and the other 20. The snakes were the size of a man's arm at the shoulder."

Many years later, in the summer of 1990, as a Relief Route was being built west of Roswell, a stunning discovery was made: a Jornada Mogollon pit village. Among the ruins was a vibrant fifteen-foot-long green clay painting of a feathered serpent. The find was rather astounding because wall paintings, especially those of discernible figures, are actually fairly rare in the Southwest.

The painting was of Avanyu, a serpent deity believed in by many Amerindians of New Mexico but more specifically those at Pecos Pueblo in northern New Mexico. There, in the mountains, was said to be a rattlesnake of giant proportions, so large it could easily swallow a man. According to legend, it was kept in the cave by a fire that burned at all times. Eventually, the snake got away and was said to have slithered off into the Pecos River. Stories of a giant rattlesnake living in a mountain cave (which also included a tribe of Indians called the Snake People) were also very prominent in the Guadalupe Mountains, in lower southeastern New Mexico in Eddy County. There, the Mescalero Apache told of sheep mysteriously disappearing, while other sheep found dead had so much rattlesnake venom in their system that their insides were nearly dissolved.

Another account goes that two anthropologists investigating tales of the Snake People back in the 1940s went exploring in the cave where the mysterious tribe supposedly still practiced. The two men were lowered into the cave via ropes operated by several ranchers and cowhands. The men

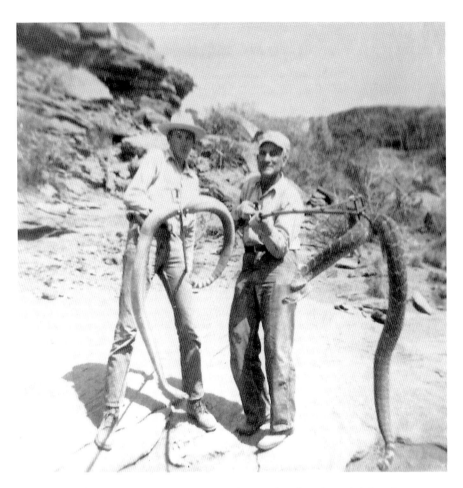

Two unidentified men pose with two large specimens of rattlesnake, or is it just the perspective of the camera? *Larkham Album #10.*

above heard a great deal of screaming coming from below, as well as loud buzzing rattles, and tried to pull the men back up. Only one of the men was pulled back out that day; he was dead and had an extremely high amount of rattlesnake venom in his system. The story ended weeks later when the government sealed up the entrance to the cave with several tons of rock. Two weeks later, a new entrance was clearly visible, with the appearance that something pushed its way out from the cave.[16]

Part II: Campfire Tales

The Stegosaurus of the Jornada Del Muerto?

The Jornada Del Muerto in the Hembrillo Basin has been the theater for many a mystery, among them giant footprints at White Sands, the search for gold at Victorio Peak, the disappearance of lawyer Albert Jennings Fountain and his young son Henry and, according to an obscure newspaper article from 1881, a dinosaur sighting.

The February 8, 1888 *Brooklyn Daily Eagle* reported this story out of San Marcial, New Mexico:

> *The section of country about San Marcial, N.M., has been aroused of late by reports of Mexicans who state that near an extinct crater near the plain known as the "Jornada del Muerto," is the abode of a monster. Some say it is 100 feet long and about two feet in circumference. The Mexicans are now afraid to venture within miles of the crater. A Mr. Alexander, who owns some mining property in that part of the country, says that he saw the serpent once while crossing the Jornada on the way to his mines. He was about half way across the plain, jogging leisurely behind his burro, dreaming of the immense wealth he hoped to realize from his property, when suddenly the burro stopped, erected its long ears, wheeled quickly around and made a mad stampede in the opposite direction. Mr. Alexander was at a loss to account for this strange freak of the burro, and was about to start in pursuit of the runaway, when he chanced to look ahead. Then his eyes gazed upon the monster. He was so struck with fear at first that, he says, his nerves had completely paralyzed, his hairs stood on end, and move he could not; he was rooted to the spot and his eyes were fixed upon the serpent. It was about a quarter of a mile from him and was traveling in the opposite direction—toward the crater. He says it appeared to be about sixty feet in length; but what surprised him most was the queer proportions of the creature. The fore parts were of enormous size, its head being fully as large as a barrel. A few feet behind the creature's head two large scales were visible, which glittered in the sun like polished shields; further back were two huge claws on either side, about two feet apart, which were all the monster had in the shape of feet. The rest of its body was comparatively*

> *small and tapering to the end of its tail. It traveled at a rapid gate, sometimes rearing its whole body up from the ground, and walked on its four claws.*
>
> What are we to make of such a strange creature? At first glance of the article it bears a similar description to a dinosaur, but the disproportion of the body is a curious addition to the report, since it brings to mind the image of an overly top-heavy animal. However, since it is noted at the end that the creature walked on four legs, the addition of two large scales may signify the author intended it to be some kind of variation on the stegosaurus.

9
Lost Skeletons and Baffling Bones

Popular newspaper subjects in the 1920s and 1930s in New Mexico were mysterious skeletons and burial sites around the state. "Skeleton Giant Indian Found in Sacramentos," dated October 20, 1927, relates how Joe Richards was doing some road work when a large rock caught his eye in the foothills of the Sacramento Mountains near Cloudcroft. Richards flipped the rock over and began digging, and he found a huge skeleton buried in a sitting position.

Several years later, a group of Native American skeletons was found by a Roswell man in 1933. The article, titled "Roswell Man Finds Many Skeletons," was one of several from the era and nothing special in the annals of history. Slightly more interesting was another article, "Skeletons Baffle Wisdom Officers from Roswell," from 1946. The only reason said skeletons were baffling was because officials weren't 100 percent positive that the remains belonged to ancient Native Americans. The burial site, discovered near Hagerman on the Vest Ranch, was investigated by Sheriff Pat O'Neill, Harry Thorne and Frank Young (sensational newspaper reports claimed that the FBI might even be called in to investigate).

The article relates:

> *Sheriff O'Neill and Messrs. Young and Thorne, with Mr. Thorne doing most of the shoveling and other hard work, went to the place where a cowboy had found a skull that had been exposed by the action of the wind on the sandy soil, and without wearing themselves down with hard work,*

This unidentified woman inspects a mysterious skull found in the vicinity of Lake Arthur, New Mexico. *HSSNM, #1478B.*

uncovered the bones of three and possibly four adults, apparently buried in a common rude grave. There wasn't a single thing near the skeletons that could give any information to even such skilled criminologists and they were at a loss to tell what manner of the people they were, how long they had lain there, how they died, or anything else.

Part II: Campfire Tales

Of course, all sorts of theories were turned loose by the incident. Most of the cow persons believed it to be the assembled bones of a group of Indians, who met their death on the lone parries and were covered up by their tribesmen. The bones had evidently been buried so long that it could hardly have been rustlers who had been run down by cowboys, wiped out and covered up.

Their condition did not warrant the conclusion that they were prehistorics wandering on the desert and perhaps dying of thirst or something. That is all guess work too.

All in all the find seems to be one of those mysteries of the open range that are never solved. Like the group found on Salt Creek, nearly a half century ago, people wondered about it and then forgot all about it. There were six skeletons at the Salt Creek burials, with not a workable or resultful clew [sic].

A humorous follow-up article on the enigma said, "Earl Dixon, who has done his share of exploring southeastern New Mexico, says the solution of the skeletons out at the Vest Ranch east of Hagerman is simple. They are Indians, he reports, basing his contention on the fact that many Indian relics are found in the area. 'Of course, if they were white folks, they probably had a flat tire and shot themselves. I never saw such a country!' he concluded."

10
LOST AZTEC TREASURE OF THE CAPITANS

The subject of lost cities full of wealth and mystery is one that never ceases to disappear. Hopes are still high that one day on the ocean floor the real city of Atlantis will be found, the riddles of Easter Island will prove to be remnants of the lost continent of Mu, a forgotten civilization rests somewhere under the frozen ice of Antarctica and even that somewhere, somehow, the fabled lost kingdom of Cibola, otherwise known as the Seven Cities of Gold, exists, waiting to be discovered out in the deserts of the Southwest. However, regardless of the fact that the once-mythical jungles of Africa and South America have for the most part been explored, the spacious barren deserts of the Southwest mapped out and satellite imagery can now pinpoint most anything on earth, people still cannot believe that their legendary lost cities do not exist.

But why then, if much of the land has been mapped out and explored, do people still believe lost cities of wealth and gold are still waiting to be found? To the faithful, the answer is simple: if you can't find them above the ground, then they must be below it.

This certainly isn't a new concept in works of fiction. The lost city of Atlantis is found underground in the 1957 adaptation of Jules Verne's *Journey to the Center of the Earth*, and more recently, when Nicholas Cage went searching for Cibola in *National Treasure: Book of Secrets*, the fabled city was found underground also (of all places behind Mount Rushmore).

In southeastern New Mexico, an elaborate Aztec treasure cave might lie hidden in the Capitan Mountains. The fantastic story begins in the

sixteenth century, during the time of the Spanish conquest of the Aztec Empire in Mexico, when Hernán Cortés took Emperor Montezuma prisoner in his own kingdom. At this time, Montezuma instructed a cavalcade of Aztecs to head north toward their mythical homeland of Aztl'an and hide most of their gold. This way the evil invaders could never possess it.

"When Cortez held Montezuma captive, the Aztec gave instructions that all Aztec gold be hidden from the Spaniards, so the legend goes and appears to be confirmed by the fact there was nowhere near the gold after the conquest there should have been," says veteran treasure hunter Jack Purcell, author of the book *The Lost Adams Diggings: Myth, Mystery and Madness*. "The legends say four groups of 1,000 Aztecs each carried the treasures to different places in the north and hid them there."

As Purcell stated above, four columns consisting of one thousand Aztecs each all set out on their own separate ways to hide their valuables, which included hundreds of tons of gold and precious jewels. One of the caravans apparently chose a spot in the Capitan Mountains nearby present-day Ruidoso to hide the gold. Some say the Aztecs knew about this cave beforehand because it was said to have been "hollowed out by a race of giants" that had once lived there.

Once the majestic Capitans were in sight of the nobles in charge of the caravan, the leaders threatened the nearly one thousand slaves in their decree with death if the mountains were not reached by sundown. By the end of the day, they reached the mountains, but in the process, many slaves perished from exhaustion and some from venomous snake bites. The morning of the next day, the Aztecs found the entrance to this lost cave of giants and made their way inside.

Most of this tale was dug up by treasure hunter Wally Hesse, which he related in an old magazine called *Treasure Search*. In the article, Hesse writes:

> *For seventeen suns they labored, building a small city in this giant cavern. On the eighteenth day, the highest born king flung himself from the high cliff, to meet the gods and declare their wishes had been carried out. That night in the light of the full moon, the queen prepared herself and her two children to offer their hearts to their terrible gods. The stone altar inside the entrance changed slowly from a dull granite grey to a crimson red as the high priest held a large pulsating heart aloft and laid it gently beside the two smaller hearts which were now devoid of all movement.*

El Capitan at sunset. Does it secretly contain buried treasure? *HSSNM, #1811*.

From then on, the queen and her children's mummified remains have allegedly watched over the doorway to the underground city built by the Aztec slaves. Upon leaving, the priest and the remaining slaves sealed the doorways so that no one else could enter or find the city. The caravan returned to Mexico with the idea that one day, when the Spanish invaders had been driven away, they would come back and reclaim their treasure.

Wally Hesse became aware of this story when he placed an ad in the *Denver Post* saying that he had $1,000 to invest in a "valid mining venture." The most interesting answer Hesse received came from an old man in Roswell, New Mexico, who claimed to have found a lost Aztec treasure cave in the Capitan Mountains. The old man told Hesse how he had found a cave in the mountains with a flight of stone steps leading down. However, he could only look into the cave, not descend into it, as the opening was too small. The old man was reluctant to dynamite the entrance, which is why he responded to Hesse's ad in the *Denver Post*.

Hesse went down to Roswell with a Jeep and some dynamite, and the two traveled westward toward the Capitans. The old man's age, however, prevented him from being able to show Hesse the exact spot, as the land was

too hard to traverse for the old timer, who had been younger when he first found the cave. "It's right over that ridge, Wally," the old man said to Hesse. "I can't make it. Go locate it. I'll take it slow and head back to camp."

In the vast Capitans, Hesse was unable to find the cave the old man claimed was just over the ridge and decided to go back to camp. The next morning, they heard on the radio that a heavy snow was coming and decided to go back home and try again later.

In the time that followed, Hesse kept in touch with the old man, and before he died, he told Hesse in greater detail what the formations near the cave opening looked like. Hesse kept researching the old man's claims even after he had died and claims to have found many facts corroborating the old man's story, although he never states in his article just what those facts were.

On a return trip to the area, Hesse said that he found an old poplar tree with carved markings of an Indian in full headgear, a turtle and an arrow. It is common knowledge to treasure hunters that turtles often represent treasures. And the arrow carved into the tree pointed in the same direction the old man claimed the treasure was located. Hesse cut the portion out of the tree and, with help from a friend in Ruidoso, took it to Eugene Chihuahua, an old Apache man living at the Mescalero Apache Indian Reservation nearby. Chihuahua said that the signs either pointed to treasure, water or possibly both.

Postcard representing a scene high in the Capitan Mountains. *HSSNM, #1410*.

Later, Hesse said he found a giant rock formation that bore similarities to a turtle in alignment with where the arrow had pointed. He mounted a formal expedition to find the cave entrance with a European mountain climber, Kurt Richardson, and an English illustrator, Julia Purcell, to map out the rock formations. The trio got close to finding the location on the very last night of the expedition, but with supplies running low, they had to turn back the next morning. Hesse's article ends optimistically, stating that one day he planned to return to the site and find the hidden city of the Aztecs once and for all.

Apparently, Hesse never found the treasure, and so far, he is the only one to have ever written about it extensively. "It's kind of hard to believe that a legend with hundreds of years of folk to folk mileage would not at the very least hold some truth," says Mickey Cochran, a longtime Ruidoso resident and co-owner of Go West Marketing. "I believe even the Lost Dutchman's Mine pales in comparison to the Capitan Treasure Cave both in value and validity. Yet, the Capitan Treasure Cave isn't near as famous… and, surprisingly, it's quite difficult to find any historical documentation. It's almost as if this treasure's history has been long hidden from the public… which makes it even more mysterious and intriguing."

Cochran has also met someone who has a similar story to Hesse's. "I have personally met someone, back when I worked as an in-house artist for Bounty Hunter Metal Detectors, who claimed with full astuteness, that he had spent half his lifetime looking for this particular cave…and in the process, had discovered symbols carved in rock that denoted this particular Aztec treasure was in close proximity to where he was hunting. He was in search of a gravitometer at the time…for he believed that the cave was well buried or maybe even caved in by the Aztecs. Thusly, the only way he would discover this treasure would be via a way to measure gravitational pull with the hopes of revealing cavities in the earth."

Several Roswell residents, such as Mark Graham, have also heard similar stories about a cave in the mountains with a series of stone steps descending to an underground city. Jack Purcell has also heard of the lost treasure of the Capitans but remains more skeptical. "I suspect the Capitans story ain't a good one, though I suppose it might be. Maybe the Aztecs had an outpost up there somewhere and were mining on that side of the Rio Grande, also," speculates Purcell.

Is there any truth though to any of the legend, if even only the caravan of Aztecs? While he doubts the Capitan location, Purcell does believe the story of the Aztecs heading northward. "One [of the treasure sites] might have

been found in Utah during the 1990s, but the feds took the relics the guy had, confiscated them under the Antiquities Act and refused to negotiate for him to get anything out of the find, so he refused to tell them where the cache is and never confided it to a soul, remained a man without an identity among treasure-hunters, but with a story that was widely circulated and the cause for a lot of us to adjust our thinkings about how we'd deal with any worked gold we happened to find."

And what of the story's most fantastic element, that the caves were carved out long ago by a race of giants?

Believe it or not, stories of lost treasures found under the watch of giant human skeletons are a fairly common one. J. Frank Dobie wrote of one such tale in *Coronado's Children*, in which a group of men dig up a cache of gold guarded by a gigantic skeleton nearly forty feet tall. In nearby White Sands National Monument are a series of footprints that for a time some thought to have been made by giant humans. And then there is the mysterious old newspaper article out of Artesia, New Mexico, from October 20, 1927, which vaguely relates the discovery of a "giant" Indian skeleton in the foothills of the nearby Sacramento Mountains.

Giants or not, does a secret underground Aztec outpost remain in the Capitan Mountains? Only the mountains know for certain, and they aren't telling.

Part III

Enchanting Locales

II

Bottomless Lakes, Lost River and Diamond Cave

You would think the strangest place in the vicinity of Roswell, New Mexico, would be the alleged UFO crash site north of town. It is not. The strangest place in Roswell by far has always been Bottomless Lakes. Bottomless Lakes State Park, the very first state park to be sanctioned in New Mexico, is located twelve miles east of Roswell and was established back in 1933 by the Civilian Conservation Corps during the Great Depression.

Of course the lakes' histories date back much further than 1933, and their discoveries and origins are fairly cryptic. Some Roswell residents whisper that the Indians that used to live near the lakes moved away from them because they felt the lakes were haunted. Even stranger is the fact Dr. James W. Sutherland, the first doctor to arrive in Roswell back in 1882, had in his possession a manuscript pertaining to the discovery of the lakes that he would never let anyone else see.

The lakes were first discovered in the 1840s by an old Indian fighter from Texas named Gabriel Thompson. Thompson was chasing some Apache toward the mountains when he came across the lakes. Although he was barely literate, Thompson wrote an account of his adventure that Dr. Sutherland somehow acquired years later. What mysteries, if any, the document held are cause for speculation. "It was one of the peculiarities of Dr. Sutherland that he didn't trust anybody, and all efforts to get access to the story of the hunter proved unavailing," wrote Will Robinson back in 1948 for an article in the *Roswell Morning Dispatch*.

The lakes would further puzzle cowboys traveling the Goodnight-Loving Trail when they attempted to determine the depths of the lakes. After tying rocks to their lariats, the cowhands threw them in the lake, and when one could not reach the bottom they would tie another and then another and so on, never finding the bottom. Thus the sinkholes were named Bottomless Lakes. What the men did not realize, however, was that the lakes were not, in fact, bottomless, but instead their lariats had simply been swept away by underwater currents.

Actually, the cowboy rumored to have named the lakes was Billy the Kid himself. James M. Miller writes in *Reminiscences of Roswell Pioneers* how he came across Billy the Kid at John Chisum's ranch in Roswell while he was there to get supplies. Billy and some of his gang were hiding out on the Pecos River near Bottomless Lakes. (Some photographs identify this hideout in the area as called "The Skillet.") Miller met Billy just a few days after the killing of Sheriff William Brady in Lincoln and said the Kid was on the counter talking about the mysterious Bottomless Lakes.

Miller wrote this in regards to the Kid:

> *I heard him say something about the Bottomless Lakes, as a natural curiosity not far from the cave in which Billy and his pals were hiding. As I was a newcomer and did not know about the lakes, I asked why they were called "bottomless"? Billy answered pleasantly enough and explained that not long before, at a big round-up, he and some other "boys" had tied together all of their picket ropes, and had tried to find out the depth of two of them, without being able to reach the bottom. Then he added (I remember his very words) "There is fish in them lakes as black as my hat," pointing to the broad-brim felt hat he was wearing.*[17]

This could well be the case, for old-timer Nib Jones remarked once to Eve Ball that "[Chisum] owned Bottomless Lakes on the Pecos, East of Roswell."[18]

Actually, most historians concur Billy the Kid was hiding elsewhere after the April Fools Day shooting of Sheriff Brady, but Billy still could have had a part in the naming of the lakes. He seems to have had a hand in nearly any good folktale in New Mexico.

Today, eight of the nine "bottomless" lakes—in actuality sinkholes ranging from seventeen to ninety feet in depth—are part of Bottomless Lakes State Park, encompassing 1,611 acres open to the public. Hiking trails are available throughout the park, swimming and scuba diving are allowed

Part III: Enchanting Locales

in the clear waters of Lea Lake and fishing is allowed in several others stocked with catfish and rainbow trout as long as you have a license.

While Bottomless Lakes are a great place to go, some people seem to be spooked by them. Why is this? Even though Bottomless Lakes may have no hard evidence to back up the urban legends purported to have happened there, one thing it does have is stories—lots and lots of stories.

One of the earliest goes that a horse drowned in one of the Figure Eight lakes (two adjoining lakes that form a figure eight) only to reappear in the other. Another tells of an old Mexican sheepherder with failing eyesight who followed his flock of sheep—jumping into the lake one after the other—to their doom, and they all sank down "clear to China."

People also like to speculate that the lakes are connected to underground currents that flow southeast to Carlsbad Caverns. The best story to exemplify this (which like any good yarn can never actually be proven) was told by a Roswell woman several years back about an incident in the 1970s. It goes that the woman and a friend were waiting in a car parked near the shore of one of the lakes and heard something moving about in the darkness outside. The two women got out of the car to look around, and when they returned to the vehicle, it had mysteriously disappeared. The car, according to the story, would later reappear in Carlsbad Caverns.

Stranger still, the woman telling the story said she thought that "something" had dragged the car into the lake. Actually, the woman later changed her fantastic story in a second telling when she claimed that she and her friends had been swimming in the lake when something with red eyes emerged from the waters. Plus, a car turning up in Carlsbad Caverns

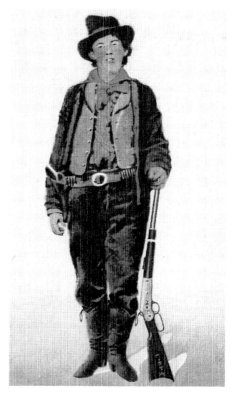

Billy the Kid seems to have his finger on just about everything in New Mexico, including the naming of Bottomless Lakes. *HSSNM, #103.*

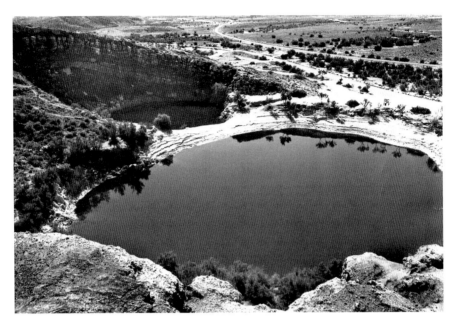

These two adjoining lakes are together called Mirror Lake at Bottomless Lakes State Park. *HSSNM, #293B.*

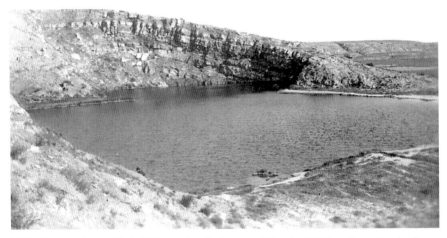

This photograph was labeled "Bottomless Lakes now falling in," likely referencing the fact that the lakes are, in fact, giant sinkholes. *HSSNM, #3844.*

would have likely made the national news. But it does make for a wonderful modern-day folktale.

Like any large body of water, Bottomless Lakes has its fair share of alleged monsters, too. A security guard boating on one of the lakes back in the 1980s

Part III: Enchanting Locales

> ## The Headless Horsewoman of Lover's Lane
>
> Another famous old Roswell spook was the Headless Horsewoman of Lover's Lane. Lover's Lane was a shady, tree-lined rural road northeast of town. It was said to have been haunted by a woman dressed in white riding a horse, only she had no head. The story goes that she had been the daughter of a wealthy banker set to marry a local man, until he left her for another woman. One night, the woman, dressed in all white, came into her ex-fiancé's home and killed him and his new wife with a shotgun. After it was over, she turned the barrel on herself, and the shotgun blast severed her head from her body. From then on, her ghostly form terrorized young lovers along Lover's Lane. One day, the old bridge she liked to haunt washed away, and she relocated—maybe to Bottomless Lakes.

was said to have felt a disturbance under the water as if a large creature had swum beneath his boat. He also was said to have glimpsed a brown hump come out of the water, evoking shades of the Loch Ness Monster. Though a cousin of Nessie is unlikely, many Roswell residents claim to have glimpsed oversized catfish in the depths of the lakes. In another fantastic story, a group of young people claimed to have been chased in their car one night by a white ghost horse near the lakes. Just as it was about to catch up to them, it reared up in the air and disappeared.

Again, although many colorful urban legends abound near the lakes, there's really no substantial evidence to back them up.

"I have not heard the ghost horse or the sea turtle stories. I have heard of the others and/or variations of such…monsters and things sinking in the Bottomless Lakes only to reappear in Carlsbad Caverns. Of course none of these stories are true," says Steve Patterson, the manager of Bottomless Lakes State Park. "There have been strange stories about these lakes for generations. I think that deep lakes in the middle of the desert just seem to promote such far out stories. Most of the stories originated many years ago when the depth of the lakes was unknown and survived in one form or another."

So in the end, you can most likely go to Bottomless Lakes State Park and safely enjoy its many wonders without having to worry about enduring your own personal horror story of being chased by ghost horses or lake monsters. This author does suggest you keep a sharp eye out for the giant catfish though.

Lost River and the Missing Motorists

North of Bottomless Lakes is another unique Roswell locale: Lost River. The place was so named because most of the river actually flows underground, linking through a series of caves and grottoes. In the 1930s, *New York Times* correspondent Georgia B. Redfield described it like this: "Desolate Lost River...for downright, flesh creeping spookiness, especially on a dismal rainy late evening, as when we last saw the dangerous looking, caving, dead river banks, two weeks ago, cuts a zigzag course east through the most weird, deserted section of country in southeastern New Mexico."

The Lost River is located nine miles northeast of Roswell and about five miles north of the old Clovis Highway. Today it is well known in the Southwest as Bitter Lakes National Wildlife Refuge, but before it was designated as such in the 1930s, it was a place of mystery and tragedy. In 1924, a man and woman had parked their automobile on a riverbank and then walked down below to look at the river. The car collapsed the bank above them, crushing the couple. After that, the cave and its crumbling banks were dynamited to prevent further tragedies.

One story goes that an old Hispanic sheepherder was digging a well in the area of Lost River when he fell into an underground lake.[19] Georgia B. Redfield writes, "After his morning's work...he climbed out of the ten foot opening he had made, ate his lunch, then jumped back into the well to resume his digging, and dropped twenty feet into a lake below. He was almost paralyzed from fright, but seeing light in the distance he began swimming and wading through shallow water until he reached safety on the banks of Lost River, half a mile below the pool, or lake, into which he had dropped."[20]

Other tales say that in 1893 an old horse trough and a coat were found in one of the Lost River caves. In the coat's pocket was said to be the bill of sale for several thousand head of cattle from a "former, long departed, cattleman." Could it have been John Chisum's? Another tale said the cave

Part III: Enchanting Locales

Left: View of the Lost River, some of which can be glimpsed under the overhang. *HSSNM, Larkham Album #3*.

Below: A party of Roswellites venture out to the overhangs of Lost River. *HSSNM, Larkham Album #3*.

was used by a counterfeiting ring long ago. There in the darkness they would make their counterfeit dollars. Though this is unlikely, there was indeed a real counterfeit ring in nearby White Oaks in 1879, of which Billy the Kid was naturally said to be a part.

On May 22, 1935, two couples from Illinois, Mr. and Mrs. George Lorius and Mr. and Mrs. Albert Herberer, disappeared while traveling through New Mexico in their automobile. Apparently, they were last seen in Vaughn, New Mexico, before they seemingly dropped off the face of the earth. An anonymous tip claimed the couples' car crashed into a lake in the vicinity of Bitter Lakes Refuge, and so the lake was dredged in search of the bodies and the vehicle. When nothing turned up, a deep-sea diver out of Houston, Texas, came along and scoured the lake bottom, looking in every crevice. Though no bodies were found, one interesting discovery was made: "A missing touring car, however, on which insurance had been collected, was

Top: Several Roswellites peer into the "unknown" of Lost River. *HSSNM, Larkham Album #3*.

Bottom: Parting shot of Lost River, today known as Bitter Lakes National Wildlife Refuge. *HSSNM, Larkham Album #3*.

found (with tires still inflated) and was raised to the surface."[21] Stranger yet, it was later learned this car did not belong to George Lorius, for his car was found sometime later in Dallas.

On June 29, 1935, two Albuquerque cowboys out riding their cattle range actually came across the couples' burned luggage and alerted the authorities. This led to the police following a trail of forged traveler's checks belonging to Lorius all the way into Texas, hence the car being discovered in Dallas. As to the alleged murderer, there had been a man with a tattoo on one arm last seen driving the car, but he was never caught.

So was the search at Lost River just a wild goose chase? Perhaps not, for later there was a second tip—this time from an unidentified man from a penitentiary—that the couples' bodies could be found northeast of Roswell in the vicinity of Lost River.

Part III: Enchanting Locales

Diamond Cave and the Seven Cities of Gold

The Seven Cities of Gold is one of New Mexico's oldest and most popular myths. However, whoever would have thought that a Roswell man would have claimed to have found them? An old *Roswell Daily Record* article written by Judy Johnston in the 1970s relates how Roswell resident Charlie Horton searched for the seven cities for exactly seven years. According to Horton, he was out hunting rocks in the country one day when off in the distance he saw "a small light, like a cigarette light. It grew to the size of a plate and then changed colors." Horton continues, "Then it shrank, grew again, changed colors, shrank again. This time it shrank until it disappeared."

Horton told his grandmother of the strange encounter. Instead of calling it a UFO like most people would, she said the light was a sign of treasure. So Horton went back to the spot of his sighting and began to dig, fully expecting to find a buried treasure chest. In his diggings, Horton found peculiar rocks, each one leading to another. After he was done, he found that he had dug a shallow trench in the shape of the number seven.

Old newspaper photo of Charlie Horton displaying a sword he found while digging outside of Roswell. *HSSNM*.

Horton claimed to study the rocks for a total of seven years. Eventually, he deducted that the rocks formed a map. One of the flat rocks, for instance, was flecked with a pattern of stars in the sky, which Horton interpreted by studying astronomy. The other rocks, Horton said, were topographic representations of mountains and landscapes. In the series of four articles by Johnston, Horton never reveals where the rocks led him, but they did lead him somewhere for certain, for he was able to produce for the reporter several artifacts he found in a cave. Among the artifacts were a large diamond ring and another ring etched with "1444." Horton claimed the cave also contained statues, jewels, gems and even raw diamonds, some etched with the head of a cow. Most mysterious is a photograph of Horton holding up a strange-looking sword, which he claimed was a "key" to the entrance to the cave.

Horton had six other men helping him (making up seven men total) excavate the cave. The article ends with Horton detailing his further excavation of the cave. "The unknown we call it. We're working on it."

And just where is this cave? Oddly enough, in the archives of the Historical Society for Southeastern New Mexico exists a handwritten document by Maurice G. Fulton, noted Lincoln County War historian, detailing a place near Roswell called "Diamond Cave." The document, dated November 29, 1936, says this:

> *This cave is the subject of various treasures and romance. One such story has it that in the early days some real diamonds were found in the mouth of the cave. Another story is that a Mexican was murdered for wages which had been paid to him and the money hidden in the cave. Still another says an Indian hid valuables and other things in this cave. And some say there are red (blood) hand prints on some of the rocks in the cave. After all this story-telling I have heard of several people going into the cave but have not been able to find them to talk to them. Without the stories and legends it is an interesting place. It is a gypsum sink which abounds in the county around for a long ways. It is roughly circular about 200 yards across and about 150 feet deep, tapering toward the bottom to a hole just large enough to crawl into.*

Assorted newspaper clippings from Roswell in the mid-1930s offer more information on the cave:

> *For years we have heard rumors of a diamond cave about forty or fifty miles north of Roswell. The stories have it that some diamonds were actually*

Part III: Enchanting Locales

> ## Forbidden Cave
>
> Another unique cave near Roswell was known as Forbidden Cave. Frank Joyce, the famed Albuquerque sportscaster who once lived in Roswell and reported on the UFO crash in 1947, said that when he was a boy he used to frequent a spot called Forbidden Cave that was eventually dynamited by Roswell. In Toby Smith's *Little Gray Men: Roswell and the Rise of a Popular Culture*, Joyce says:
>
> > *There used to be caves west of town, along a ridgeline out there. Kids were always getting lost in there and at least one boy never came out. One day I went in there with some Boy Scouts. We went to a place they called Forbidden Cave. It was a hole that dropped straight down and Sulphur fumes were coming out of it. Anyway, we made a ladder and went down in. What I saw scares the daylights out of me to this day. Sitting on a ledge in that cave were two alligator-like things. Four feet long each. These weren't Gila monsters. They were much, much bigger. I climbed right back up that ladder quick as I could. The city fathers finally went in and dynamited the caves. Closed them up.[22]*

found in the cave and were taken to Dallas and sold to jewelers there and were pronounced real diamonds. As to the truth of the stories we cannot say, but we did get some firsthand information from Mr. Earickson on the cave, for at one time years ago he had actually been in it.

He was one of a small party entering the cave. One of the party was a government mineral expert. They made their way inside through a small entrance barely large enough to admit a large man but found large cavities within. They were gone for hours and believed they had gone down probably two thousand feet. It required an hour and a half to make the return trip. They had to use ropes in many places to ascend or descend. The air near the bottom was found to be quite bad and often extinguished the lights of their lanterns.

> *The mineral expert said he saw no indications of diamonds but declared there was an immense amount of pure plaster of pairs within the cave. Some chambers were found that were large enough to hold a large building.*
>
> *Another story about this cave that seems to be rumor is that one man found the diamonds there and actually had them pronounced to be diamonds and sold them as such.*
>
> *Anyway, it is evident that there is a big cave up north of Roswell, whether it is of value or not.*[23]

Another article relates that Diamond Cave was located "somewhere in the barren terrain of the Half Way House country, in a split distance between Roswell and Torrance." The article goes on to tell a tale about a group of cowhands out on the trail, the cook of which finds a piece of "pretty glass" he later takes to San Antonio, where it is appraised as a "true diamond."

Could this mysterious "Diamond Cave" be the same one found by Horton? In the end, perhaps all that one can take away from the legend is the great irony that Roswell's contribution to the legend of the seven cities of gold manages to involve a UFO.

12

MYSTERIES OF WHITE SANDS

Giant Footprints, Dinosaur Petroglyphs and the Lady of the Sands

The White Sands can be deceiving. Though it looks as peaceful as an endless stretch of sandy beach without an ocean, instead, it is itself the ocean, ever shifting and drifting nearly one mile every year. With its broad open expanses of roving sand dunes with sparse vegetation to hide anything, it looks like the last place for a mystery, but this is not the case, for both above and underneath the sands lie a menagerie of mysteries.

An old newspaper clipping from the HSSNM archives titled "Indian Pictures Near White Sands"[24] relates a short news item regarding dinosaurs, of all things. Of the perplexing pictographs it states, "Other pictures represent dinosaurs, except that they have horns; still others represent animals in flight; strange insects, and butterflies; and human faces drawn over the corner of a rock with one eye looking each way." The clipping was dated February 16, 1934. It is not the only case of someone finding a pictograph they believe to be of a dinosaur in New Mexico. Similarly, at Three Rivers there is a pictograph of a ram often thought by many to possibly be a dinosaur.

And then there are White Sands' mysterious "giant footprints." In the U.S. Department of the Interior booklet *The Story of the Great White Sands*, it is written:

> *In the fall of 1932 Ellis Wright, a government trapper, reported that he had found human tracks of unbelievable size imprinted in the gypsum rock on the west side of White Sands. At his suggestion a party was made*

to investigate. Mr. Wright served as guide, O. Fred Arthur, Supervisor of the Lincoln National Forest, Edgar Cadwalader and one of his sons from Mountain Park, and the writer made up the party. As Mr. Wright had reported there were 13 tracks crossing a narrow swag, pretty well out between the mountains and the sands. Each track was approximately 22 inches long and from 8 to 10 inches wide. It was the consensus that the tracks were made by a human being, for the print was perfect and even the instep plainly marked. However there was not one in the group who cared to venture a guess as to when the tracks were made or how they became of their tremendous size. It is one of the unsolved mysteries of the Great White Sands.

And believe it or not, still no one could "venture a guess" until a full fifty years later. Finally, in 1981, a group from the New Mexico Bureau of Mines and Mineral Resources studied the footprints after being alerted to their existence by archaeologist Peter Eidenbach. The researchers deducted the prints didn't belong to a giant human but rather a prehistoric mammoth, a prehistoric camel and another unidentified mammal made in the Pleistocene era.

To switch from the prehistoric to the supernatural, one of the more popular ghost legends of the White Sands concerns a member of the Francisco Coronado expedition of New Mexico in 1540. The conquistador's name was Hernando de Luna, and he had left behind his lovely fiancée, Manuela, in Mexico City. When de Luna was wounded in battle along the Jornada Del Muerto by a group of Apache, he staggered into the nearby White Sands and died there. Manuela left Mexico City to come looking for him and disappeared in the White Sands, where to this day she is known as the Lady of the Sands, or alternately as the Legend of Pavla Blanca. Every night, she can be seen in her white wedding gown searching for her lost lover. Others say the winds and heavy breezes whip up white sand into the air over the dunes, giving the illusion of the beautiful figure in her wedding dress.

Roswell writer Will Robinson wrote of a trip to the White Sands along with Pedro Cassini in the 1930s:

One evening old Pedro was counting his beads as the sun set in a burst of glory over the San Andreas Mountains. "The White Lady will rise again when the moon comes over the Sacramentos," he said. "Twice it will be for me. Once more will be the last, as it was with my father and many others who have seen her."

Part III: Enchanting Locales

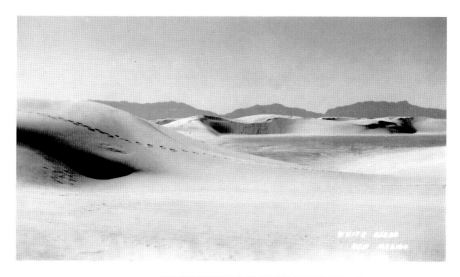

Above: Footprints left along the White Sands. *HSSNM, Larkham Album #3*.

Right: Tiny footprints left behind in the sand. *Courtesy of Donna Blake Birchell*.

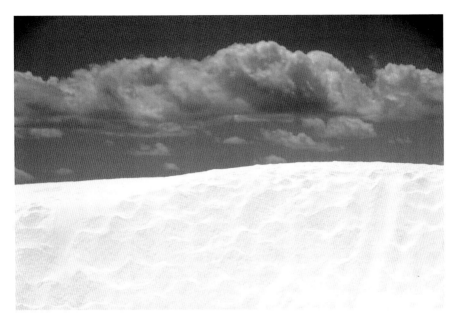

Another stunning view of White Sands, one of New Mexico's greatest attractions. *Courtesy of Donna Blake Birchell.*

The wind was coming across the plains of the Sacramentos from the southwest in long, steady flows, but not so very hard. Most likely it bounced off the prairies at times, and when it struck it moved things.

"There she is," said one of the men pointing to the top of one of the great dunes. Here the wind seemed to be deflected, and high in the air rose a spiral of white, light enough for the mountains to be seen through it, but positive enough that there was no mistaking that the White Lady was walking again in the vast area of alabaster covering 270 square miles. Old Pedro continued to count his beads until the White Lady gathered her fleecy garments about her and vanished into the night.

I never again saw the White Lady though the years of patrol the ears were always alert to see her. It is not often that she comes, and the primitives are glad of it. She is lovely, but no man or woman can see her but three times and live.[25]

13
Hermits of the Guadalupe Mountains

The mystique of the daunting Guadalupe Mountains, an ancient Permian Reef that begins in New Mexico and departs as the highest point in Texas, has drawn many cultures to live within their craggy depths for at least the past twelve thousand years. Evidence that prehistoric man, such as the Jornada Mogollon and Paleo Indians, sought shelter in the caves and limestone overhangs has been exposed by many formal university archaeological digs and individual amateur finds in the mountain canyons.

Native Peoples

Pottery shards, bits of sandals made from the local yucca plant, projectile points, baskets and human remains have been some of the more recent discoveries. In more modern times, the Mescalero Apache, or N'de (In-deh), a nomadic hunter tribe—according to their tribal website, "no other Native Americans in the Southwest caused the terror and constant fear in the settlers as the Apaches did throughout their existence"—used the resources available in the Guadalupes as sustenance as they followed the seasons, plants and animals available during these times.

Right: Hermit's Cave was a treasure trove of early Basketmaker artifacts, many in pristine condition. *Courtesy of Southeastern New Mexico Historical Society.*

Below: Many prestigious universities vied for the opportunity to study the contents of Jim Pickett's cave home. *Courtesy of Southeastern New Mexico Historical Society.*

Part III: Enchanting Locales

Rumored to be a source of evil by the conquering conquistadors because of their foreboding appearance, the Guadalupe Mountains have been inspiration for spectacular tales of Spanish gold mines, outlaw roosts and brutal battles between the Apache and the U.S. government.

The tribe's presence in the mountainous terrain was a source of anxiety for the early ranchers who began to trickle in from the East. The Apache, on horses taken from the Spaniards, were known for their cattle raiding expertise, and only the bravest of settlers would attempt to ranch close to their domain. As the towns increased and encroached on the native lands, this mighty tribe, led at different times by the famed chiefs Cochise, Geronimo, Mangas Colorado and Victorio, were forced on the 463,000-acre reservation in Mescalero, New Mexico, where they reside today.

The threat of the Apache, or "the Apache problem" as the tribe was described by the U.S. government, was lessened in the late 1800s. Ranches began to pop up throughout the Guadalupes, and sheep and cattle were brought in as the primary industry.

James Henry "Jim" Pickett

One of the canyons in the Guadalupes that saw much activity—from the native peoples, government troops and settlers—was Last Chance Canyon, a New Mexico Registered Cultural Property due to the discovery of an Apache cavalry battle site. Picturesque, quiet and with a fast-running stream as a water source, it is the perfect hunting or recreation spot. This canyon was also called home by an eccentric man, James Henry "Jim" Pickett, who was known to the surrounding ranchers as the Hermit of the Guadalupes.

Many stories filtered down from the mountain to the small community of Queen and then on to Carlsbad, creating an almost morbid interest in the life of a man who chose to live in an overhang cave rather than a conventional house for thirty-five years. Local folklore has Pickett living in his cave as early as the 1920s, but there is proof via the census that he lived in the area in 1910.

In that census, Pickett was a twenty-five-year-old ranch hand who stated he was born in Missouri. By 1920, the census told a different story—he was listed as forty-nine and from Texas, the first of many mysteries to surround Pickett.

Speculation swirled about Pickett's true history. Was he a music teacher, a goat rancher, an expert stone mason, a mechanic, a ranch hand or a defrocked minister? The only thing people agreed on was the fact the hermit was an extremely intelligent man who, some said, "did not belong in the hills."

According to public record, Pickett was allotted 640 acres (one section) in the Guadalupe Mountains by Mary Pickett. The relationship between Jim and Mary is unknown, but it is believed she might have been his wife. Supposedly, he went west to escape the memories after her death. Pickett also lived in a chosa near Seven Rivers with a large bull snake as company.

Many of Pickett's neighbors were astonished to hear haunting violin music coming from Last Chance Canyon. On top of everything else, Pickett carved beautiful fiddles, which he loved to play during gatherings at the Montgomery Ranch and give as gifts to lucky recipients. Family history states that Pickett's entire family was extremely musically inclined, and the violin was the family's instrument of choice. But James was talented on any instrument. He would delight his ranch neighbors by switching from the fiddle to the guitar with equal skill at social get-togethers. Old timers chuckled that his solitary violin strains would startle deer as well as their hunters, with many claiming the canyon was haunted.

Jim was known to walk to Queen from his perch in Last Chance Canyon just to visit, gather mail and talk politics. Pickett was renowned for picking fights with the locals over current events, and when their opinions were not the same as his, he would storm off, only to return in a few days and commence the exact conversation.

One conversation Pickett would not return to was that of his past. Full of secrets, Jim would turn his back on those asking the prying questions and refuse to speak of himself. According to an article by special reporter for the *Current-Argus*, Valerie Cranston, Pickett "may not have been a true hermit in the sense of the word, but he was eccentric in behavior and selective when socializing."

A well-known story told by Pickett gave evidence as to the harshness of life in Last Chance Canyon and what it took to survive in that environment. Close neighbors, the Montgomerys, tell of Pickett arriving at their ranch with a face described as "white as a sheet" and a wild look in his eyes.

After a hunting trip into the canyon, Pickett had bagged a large tom turkey, which would serve him well for the next several months. The bird was so large, in fact, that the hermit was forced to drag it along the ground to his cave. Last Chance Canyon is a high desert environment

Part III: Enchanting Locales

Jim Pickett almost became a meal for a young mountain lion. *Courtesy of Southeastern New Mexico Historical Society.*

with mesquite trees, pine and scrub oaks, so when he felt a tug on the fowl, he did not pay attention, thinking it was a stray bush occasionally snagging on the bird.

After several miles of this activity, and with the terrain becoming more sparsely populated with vegetation, Pickett finally decided to investigate the source of his annoyance. To his great surprise, his competition for the tom was a large mountain lion that had decided that turkey sounded like a tasty treat for dinner as well, standing only the width of the bird from him.

Pickett told his neighbors, no matter how hungry he had been, his appetite suddenly went away at the sight of the large cat. It ultimately won the silent battle for the bird, and Jim felt lucky he had not become the entrée. "That old lion had an easy meal."

Pickett befriended a man by the name of Johnnie "Behind the Deuce" Williams in 1910. Legend has it Johnnie acquired the name by being dealt four deuces in a shady poker game. The two men explored the Guadalupe

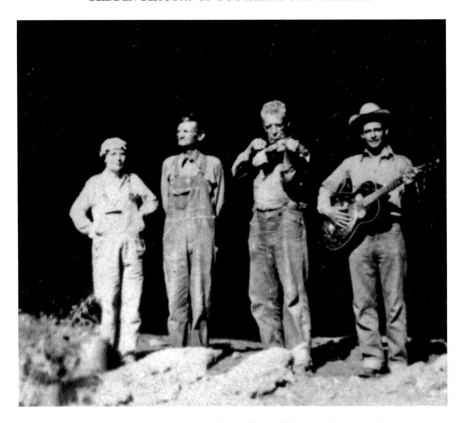

A man who could play many instruments, James Henry Pickett preferred the haunting strings of the violin. *Courtesy of Southeastern New Mexico Historical Society.*

Mountains and came upon a cave in Little Pine Canyon and built a cabin at the front entrance, complete with a garden and a picket fence.

Adding to Pickett's mystique was a story circulated by Cranston that tells of Jim and Johnnie exploring adjoining caves and finding numerous human skulls, most likely Native American. The skulls were collected and placed on the pickets of the fence posts around their garden as a joke. "Leftover" skulls were "placed throughout the mountains on sotol stalks," which reportedly gave people an "eerie feeling about him."

After Johnnie left the mountains in 1915, Pickett moved into the cave, where he was to remain for thirty-five more years.

According to a 1938 article in the *Daily Current*, Jim Pickett was also given credit for building a stone chimney in Queen, New Mexico, in 1911 for Lee Middleton, who purchased the original property from J.W. Tulk. This solitary monument is all that is left of the high desert town, which comprised

PART III: ENCHANTING LOCALES

a store, a post office, a school and a church. The monument was constructed out of local limestone and preserved by the men of the Dark Canyon Camp of the Civilian Conservation Corps in 1938.

Perched on the side of the highway, the chimney is also the location of a geological survey marker indicating the site is 5,845 feet above sea level. Queen's remains a popular spot for hunters, sportsmen and day trippers. The modern-day café is home to one of the best green chile cheeseburgers in the state.

In 1938, Pickett was asked to move out of his cave, which was referred to as "Hermit's Cave," so that Dr. Edwin Ferdon, the state archaeologist for the laboratory of anthropology located in Santa Fe, New Mexico, could excavate the dwelling Pickett had called home for thirty-five years. Assisting Dr. Ferdon were Dr. Bertrand Schultz, Bill Burnet (a local amateur archaeologist) and John M. Corbett. This would be one of many expeditions by scientists and universities to study Pickett's cave.

Many artifacts were unearthed from the cave floor that were extremely exciting to the excavators. Mammoth bones dating back eight to ten thousand years, projectile points, sandals, native burials, extinct animal bones and spears were just a few of the items found.

Built from local limestone by hermit James Pickett, this chimney is the sole survivor of the small frontier town. *Courtesy of Southeastern New Mexico Historical Society.*

McKittrick Cave saw much action at the turn of the century as a travel destination and a hermit's humble home. *Courtesy of Southeastern New Mexico Historical Society.*

After each excavation—of which there were three—Pickett's cave was restored for him so he could continue to live there. Eventually, the hermit moved down the canyon and set up housekeeping in a neighboring cave while his permanent residence was being studied. The cave furnishings included a two-leg table, a bedframe, part of an old trunk and a clock. The hermit was also known to have a great love for Post Toasties.

By 1944, Pickett had decided to move to Carlsbad, where he went to work at the Carlsbad Army Air Field and repaired violins on the side. An advertisement in the *Carlsbad Current Argus* had Pickett living at 808 West Greene Street, where he repaired "fiddles only." Ken McCollum, a neighbor of his, reported visiting him in the Carlsbad hospital at one point, only to find the old hermit perched on the side of his bed much like he used to do on the limestone ledges in his beloved canyon.

Cranston's article reports a sad end to James Henry Pickett, as he is thought to have died alone in the New Mexico State Hospital in Las Vegas, although the date of his death is unknown.

Part III: Enchanting Locales

Robert B. "Bob" Brookshire

At the same time Jim Pickett was living in Last Chance Canyon, another character, known as Robert "Bob" Brookshire, appeared in the area. Born in Indiana as the second oldest of seven children in March 1842 to Sam and Sarah Brookshire, Robert helped his parents in the raising of his younger siblings by working on the family farm.

According to the 1928 account of Brookshire's early life in the *El Paso Herald*, Bob came to New Mexico from Texas in a wagon drawn by two six-ox teams. In 1882, Brookshire took those teams across Pontoon Crossing, which spanned the Texas part of the Pecos River with a bridge made of whiskey barrels held together with chain and covered by wooden planks. As the animals started across the pontoon bridge, water circled their feet, and the panicked oxen stampeded across the unstable bridge. Those who witnessed the sight said that the teams made it across the river in record time.

An advertisement for R.B. Brookshire & Company shows up in the El Paso newspaper. As a headstone carver and stonemason, his shop was located in the perfect spot—next door to the Concordia Cemetery, which would play host to famous gunslinger John Wesley Hardin in 1895.

When Brookshire arrived in the tiny village of Seven Rivers, he found it to be a booming spot for his headstone business. According to legend, at least thirty-seven graves contain men who died with their boots on. During the excavation of the Seven Rivers Cemetery in the 1980s, it was found to be true. Very few of the people buried in the Seven Rivers Cemetery died of natural causes or old age.

Brookshire would also conduct business with Captain Lea when his store was the only structure in the present-day Roswell. Lea opened his store with help from Kansas jobbers and carried boots, hats, shirts, saddles and ropes, as well as most anything needed to survive in the region. Most of his customers were local ranchers who purchased their items on credit, to the tune of $8,000. Lea's creditors were tire of not getting paid, so they decided to shut him down, but when they saw the books and the empty shelves, they agreed to give him another $8,000 in merchandise.

As a stonemason, Brookshire also carved grindstones from the sandstone he found in Rocky Arroyo (near present-day Carlsbad), which he would take to Lea's store to sell. He wanted twenty dollars for the wagonload of stones, but Lea was only able to give him ten and supplemented the rest with merchandise.

Ornate headstone carvings were a major source of income for hermit Bob Brookshire, who was known to sign his work. *Courtesy of Southeastern New Mexico Historical Society.*

Many legends swirl about the hermit, including that he was an excellent gunman and had several skirmishes with the Apache and narrowly escaped being captured by Geronimo when the chief was raiding Socorro County. Brookshire was instrumental in helping the few ranchers in the Seven Rivers area who were being plagued with horse and cattle raids by the local native tribes, as he was an expert gunman and tracker.

Another tale has him going up against the famous outlaw Billy the Kid and living to tell the tale. The day of Billy the Kid's famous escape from the Lincoln County Courthouse nearly had one more victim. After killing Deputy Sheriff J.W. Bell and jail guard Bob Olinger, Billy, still holding the Winchester rifle, confronted a surprised Bob Brookshire, who had just stepped out of the Wortley Hotel onto the dusty street.

Billy reportedly told Brookshire, "Go back, young fellow, go back. I don't want to hurt you, but I'm fighting for my life. I don't want to see anybody leave that house [Wortley Hotel]." Brookshire complied and lived to see another day. He had been lucky enough to be given room and board at the Wortley in exchange for his headstone artistry.

By 1910, the census shows Brookshire as a sixty-seven-year-old widower who seemed to withdraw from public and took to the comfort of McKittrick Cave, where he had staked a homestead claim. Brookshire was convinced that there were rich deposits of onyx in the area.

Due to his living conditions, and the deterioration of his mental state, citizens of Carlsbad became concerned for his health. Brookshire was declared insane in 1902 according to an April 5, 1912 article in the *Carlsbad Current Argus* but continued to survive in the cave on his own until at least 1913.

In a March 29, 1912 article in the *Carlsbad Argus*, Brookshire is described as the "Hermit of McKittrick Cave." His cave was situated approximately

Part III: Enchanting Locales

eighteen miles west of Carlsbad and was a popular spot for groups of people to visit on a Sunday afternoon. Caravans of wagons laden with picnic lunch baskets and ladies dressed in their cave-exploring dresses and boots were escorted by men on horseback to visit the cool underground delights of the caves.

The location of McKittrick Cave, in McKittrick Hill, is not to be confused with McKittrick Canyon on the Texas border in the Guadalupe Mountains National Park. Felix McKittrick, former ranch foreman for John S. Chisum, was the original owner of both locations and had several ranches in the area that he named after himself, causing a bit of a mix-up.

The hermit is described as a sedentary man who collected water in tin cups from under the stalactites (since the nearest source of water was several

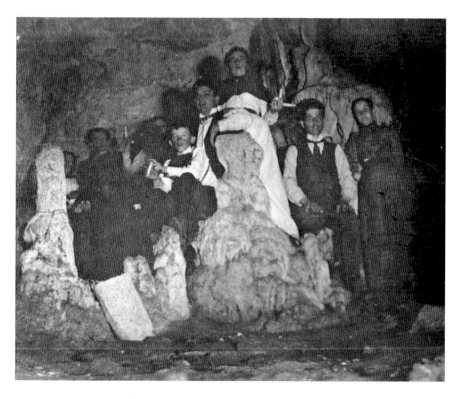

Look closely, and you will see several headstones in progress among the early spelunkers. *Courtesy of Southeastern New Mexico Historical Society.*

miles away at a ranch house) and had no knowledge of the outside world except for the stories he was told by the Sunday visitors. What the article did not say was that Brookshire was an expert stonemason and headstone carver and drew his daily subsistence from cooked wood rats that also lived in the cave. The combination of the cave water and the rats—along with a fascination he had with mercury—might have eventually led to the deterioration of his mental state.

Visitors would find remnants of Brookshire's handiwork strewn about the entrance to the cave where he had a shanty. His work was seen in cemeteries throughout southeastern New Mexico, especially Roswell, Seven Rivers and Capitan.

It was said Bob made $150 a month carving his elaborate headstones early in his career as he traveled with his toolkit throughout the region. He was famous for signing his work and saying he made headstones for "men who met death when might was right in the southwest."

Later in life, the hermit would make money by giving tours of his cave to the many visitors and by carving shapes from the cave formations, which he sold as souvenirs. Visitors were known to scratch their names on the rock walls at the entrance to the cave as a makeshift register, with some dating back as far as 1894. A 1912 *Carlsbad Argus* article stated that Carlsbad resident Arthur Linn and a few others got together and purchased a large blank book for Brookshire's visitors to use to record their social calls.

Like his fellow hermit James Pickett, many believe Brookshire ended up at the New Mexico State Hospital in Las Vegas, New Mexico, around 1912 for insanity, but family records indicate that he went to live in Texas with his sister at one point. Whether he remained there until his death is still a mystery.

Part IV

The Military in Southeastern New Mexico

14
MILITARY GEOGLYPHS, POW CAMPS AND FORGOTTEN ARMY AIR FIELDS OF SOUTHEASTERN NEW MEXICO

New Mexicans paid a heavy toll in World War II, as they suffered many casualties—especially during the Bataan Death March, where 1,800 New Mexico soldiers of the 200th Coast Artillery Regiment were forced to participate and less than half made it home alive. Of the ones who were lucky enough to be rescued, another half were to die all too soon at home from the ravages to their bodies they suffered at the hand of the enemy.

Many of these brave men were from Eddy County, which also includes the towns of Artesia and Hope, in southeastern New Mexico. Their stories display true valor and bravery.

Deployed to the Philippines in September 1941, these men had no idea the horrors that would befall them in three short months. When the Japanese bombers attacked on December 8, 1941, it was the antiaircraft artillery of the 200th that was the "first to fire." It was during this battle that the 515th Coast Artillery was formed from the ranks of their brothers in the 200th.

Although they fought a valiant fight, their weapons were not enough to stop the insurgence. When the Japanese forces landed on December 22, 1941, the American troops decided to split and retreat toward Bataan. It was there that American and Filipino fought side by side in the attempt to defeat the larger Japanese advancement for four months until the battle for the Bataan Peninsula ended on April 9, 1942.

With the battle lost, over seventy-five thousand American and Filipino troops surrendered and became Japanese prisoners of war, but this was to be the least of their worries. The large numbers of prisoners were

Above: The 200th Coastal Artillery was the first to fire in the Philippines and went down with a fight. *Courtesy of Southeastern New Mexico Historical Society.*

Left: Captured American and Filipino soldiers raise their arms in surrender at the overwhelming Japanese forces at Bataan. *Courtesy of Southeastern New Mexico Historical Society.*

Part IV: The Military in Southeastern New Mexico

German POWs work on North Spring River in Roswell, New Mexico. *HSSNM #1094.*

overwhelming to the Japanese, who then forced the soldiers to walk sixty-five miles to confinement camps without water or food. Because of this, nine thousand Filipino and one thousand American soldiers died from exhaustion or maltreatment.

Those who were not killed in the initial battle and death march were taken to Japanese POW labor camps, where some succumbed to the horrors that awaited them there. Overcrowded hell ships were used to transport some to POW camps in the Philippines, Malaya, Thailand, Burma, Singapore, Japan and even China, as well as many more sites. These ships were sometimes targeted unknowingly by U.S. troops, unaware that their compatriots were aboard.

New Mexico and the country owes much to their military service men and women who have given up so much for our freedom.

POW Camps of the Region

During World War II, many of the towns in southeastern New Mexico played host to the military by providing air bases.

Roswell is most famous for housing the *Enola Gay*, the aircraft from which the nuclear bomb used on Hiroshima was dispatched. The Roswell Air Field would also be the sight of much activity on the evening of July 3, 1947, when the alleged UFO crash landed in the desert near the town. Today, because of its immense landing strip, the airfield has seen several U.S. presidents land aboard Air Force One and is now home to an aircraft once owned by singer Elvis Presley.

Due to the isolation of the southeastern New Mexican desert communities, the government thought it would be a perfect solution to a growing problem, and they became host to German and Italian prisoners of war. Major camps were set up in Carlsbad, Roswell, Artesia, Tularosa, Hobbs and Fort Stanton to house the large number of captured enemy forces. Generally placed in a rural location, the camps were orderly and well maintained.

Roswell's Orchard Park Camp held mainly German troops from General Rommel's elite Afrika Korps and later saw Italian supporters of Mussolini. A former Civilian Conservation Corps (CCC) camp turned army barracks for the now defunct Carlsbad Army Air Field proved to be the perfect setup in Carlsbad for the German prisoners who would be housed there. This camp was located near the present-day Carlsbad Medical Center and Heritage Park. (A hotel and convenience store now occupy the spot.) Other temporary camps were erected close by in the small satellite communities of Otis and Loving.

Local farmers benefitted most from the camps, since the main activities of the prisoners included cotton picking and tending fields. At first, the farmers were not too impressed by the work that the German soldiers achieved during the day—seeing only a forty to sixty pound picking yield. By the end of the first month, the rate had grown to over one hundred pounds per soldier at a wage rate of two dollars an hour for their efforts. Many farmers felt the prisoners were more trouble than they were worth at times.

The government began to accuse many of the POW camps in the United States of "coddling" the prisoners, but that was not the case in Carlsbad. Many of the prisoners complained that the work of picking cotton was too hard. There were feelings of animosity toward the government for placing the prisoners here, mainly due to the fact that the citizens were being rationed on sugar, bacon and meat, but the camps were readily supplied

Part IV: The Military in Southeastern New Mexico

Left: Norden Bombsight was billed as the turning factor of the war. *Courtesy of Southeastern New Mexico Historical Society.*

Below: Bombardiers from all across the United States and China trained at the Carlsbad Army Air Field. *Courtesy of Southeastern New Mexico Historical Society.*

without problems. The prisoners were treated with great care and never tortured or interrogated, unlike their American counterparts abroad.

Sundays at the camps became a local attraction, as this was the day the soldiers played soccer, and many had never seen the sport. Locals, especially schoolchildren, were instructed to not tell the prisoners their location or to show them any of their books or maps. This was not all that difficult, as the majority of the soldiers spoke only German.

Some of the locals were known to sneak a soft drink or treat to the prisoners from time to time. The prisoners would make wood carvings, cigarette cases, ashtrays and lamp bottoms from scrap wood they found within their fenced camps to be traded to the residents for items not provided by the camps, like cigarettes. These finely crafted items are highly prized today.

In an article written by *Carlsbad Current Argus* newsman Jim O'Hearn, the story of German prisoners Johannes Rombowski, twenty-two; Heimrich Becher, twenty-two; and Oscar Rudat, nineteen, comes to life. On April 1, 1945, the three aforementioned men breached the fence of the Carlsbad Camp and began their escape to Canada. Wearing raincoats that covered their clothes marked with a "PW," the men somehow scaled the barbed wire–topped fence and headed north. A passerby on the highway noticed the three suspicious men and called the authorities at a small grocery store along Highway 285. The three were quickly apprehended seventeen miles north of Carlsbad and taken to Orchard Park Camp, which was located fourteen miles southeast of Roswell, for further detention.

In the words of a former POW at Orchard Park, Alfred Dietrich of Essen, Germany, who had come back to visit later in life, "The freedom we lost we wanted to have again."

By November 1945, there were over 875 prisoners working in Eddy County alone, but these numbers were beginning to reduce as the war began to subside. Mid-January 1946 saw the end of the prisoners' sixteen-month stint as POWs. The residents of the Carlsbad and Artesia camps were taken to Roswell for transportation back to Germany.

Evidence of the existence of the POWs can be seen throughout southeastern New Mexico, as the prisoners were known to have embedded an iron cross into the concrete used to build the ditches, walls and dams they completed in the region. A swastika can be seen carved into the concrete work at Avalon Dam near Carlsbad.

Some of the prisoners were so taken with the countryside that they returned after the war to settle with their families, and still others returned for visits—finally able to see everything without restrictions.

Part IV: The Military in Southeastern New Mexico

Carlsbad Army Air Field

Due to World War II, military bases sprang up around southeastern New Mexico. One such base was the Carlsbad Army Air Field (CAAF), which was located on the same piece of land the present-day Cavern City Air Terminal and Carlsbad Industrial Park occupy.

Vital to the war efforts, the air base sat on 1,678 acres of land and was a city within itself. The U.S. War Department authorized over 7,000 pilots and 3,600 bombardiers and navigators to be trained annually in 1940. Good weather conditions and flat terrain encouraged the government to choose Carlsbad as the site of an Army Air Corps training center in 1942 over other possible locales.

The original barracks for the men were located at the CCC camp north of Carlsbad. Later, this same housing was to be used for the German POWs.

Initial focus of the training center was to be only on a twin-engine pilot and bombardier school, but this was to change quickly, as expert gunners, navigators and bombardiers were brought in for training. The twelve-to-eighteen-week course allowed the pilots to perfect their bombing skills, as they dropped an average of 160 concrete practice bombs during a twenty-four-hour period of time. Remnants and complete practice bombs can still be found around the region.

Carlsbad Army Air Field was chosen to house an extremely top-secret device, and it came into town under the darkness of night and heavily guarded—the Norden Mark XV Bombsight. Constructed by Swiss engineer Carl Norden, who had immigrated to the United States in 1904, the Norden Bombsight was to revolutionize the accuracy of bombing. Norden was a driven man who worked sixteen-hour days and thought a suntan was a sign of laziness. Navy officers were said to have referred to Norden as "Old Man Dynamite." Norden, a devout Christian, developed the bombsight as a means to save lives in war; he would have been stunned to know that his device was used by the bombardiers of the *Enola Gay* as they dropped the "Little Boy" nuclear bomb on Hiroshima, Japan.

This bombsight was to give pilots pinpoint accuracy, and it was said, when used correctly in perfect conditions, that it could drop a bomb into a pickle barrel from twenty thousand feet. The U.S. government spent $1.5 billion on this project in 1942. Comparatively, the entire Manhattan Project cost $3 billion in the same time frame.

Pilots were instructed to lock up the bombsight each night in a special concrete vault due to the sensitivity of the machine. They had to swear

Bomb casing used for Project X-Ray, otherwise known as the bat bombs. *Courtesy of Southeastern New Mexico Historical Society.*

Premature awakening of bats caused havoc at the Carlsbad Army Air Field, starting several fires on the base. *Courtesy of Southeastern New Mexico Historical Society.*

never to divulge any information about the device to anyone, even under duress.

The War Department bought ninety thousand of the Norden Bombsights at a cost of $14,000 each, and they were installed into the bombers under armed guard. An incendiary device was built into the bombsights so they would explode should the airplane crash to keep it out of enemy hands.

The only problem with the Norden Bombsight was that it was designed to work at low altitudes at a relatively slow speed. This was not possible in real war situations where the planes were flying at high speeds and altitude to avoid being shot down. It was close, better than the other devices at the time, but not the miracle it was touted as being—not to mention, it was extremely difficult to use.

A display curated by the Carlsbad Museum and Art Center of the actual Norden Bombsight used at the CAAF is available for public viewing at the Carlsbad Airport. Although the base is no longer intact, the vault building was preserved and moved to Veterans Memorial Park in Carlsbad.

Of special interest were the two classes of Chinese National Airmen who also trained as bombardiers at the CAAF. Relatives of these graduates have been in contact with members of the CAAF preservation society and emphasized how much the cadets enjoyed the New Mexico countryside and the kindness of the residents and have returned to visit.

Part IV: The Military in Southeastern New Mexico

Another notable fact about the CAAF is that it proudly housed women as well. Many served as test/transport pilots and flew in the AT-11 Bombers from other bases to be housed in Carlsbad.

The Carlsbad Army Air Field was also a site for a developing World War II program titled "Project X-Ray," better known as bat bombs, which used the indigenous bats that resided in the many caves in the region. The whole idea of the project was to use the bats as a stealthy means in which to sneak up on the enemy while carrying ordinances with napalm into their camp and cities.

Developed by Lytle S. Adams, a Philadelphia dentist and friend of First Lady Eleanor Roosevelt, the Project X-Ray concept was to strap tiny timed incendiary devices to hibernating Mexican free-tailed bats and drop them from a bomber at dawn. Parachutes attached to the main bomb casings would disperse the bats into Japanese cities unseen. The idea behind this plan was to create chaos when the devices set Japanese buildings on fire, as most were built out of paper and wood.

With the bats' sonar ability, it sounded like a great idea, but it quickly turned, as some of the test bats awoke prematurely and began to fly into buildings and vehicles at the CAAF. Several fires resulted, including the car of the commander.

There were twenty-six precision bombing targets around Carlsbad, Roswell, Hobbs and Hope, New Mexico, which are approximately 330 yards and 1,800 feet wide in size. A majority of them were illuminated for night runs. Some of the targets had wooden pyramids located some 20 feet to the side that served as bull's-eyes. These can still be seen from the air today.

Military Geoglyphs

Geoglyphs were more elaborate targets perfectly carved into the desert landscape around the air bases. Large dirt berms in concentric circles formed bulls-eyes surrounded by the whitewashed outlines of factories, plants and ships, complete with smokestacks. Most were highlighted with a Nazi swastika in the center of the target.

To the naked eye on the ground, these looked like oddly shaped dirt mounds, but from a Beech AT-11 pilot's perspective, they proved to be the perfect training for what they might face in war. Damage from the cement- or sand-filled practice bombs are still evident. On occasion, incendiary devices were also used at night to train for night bombing raids.

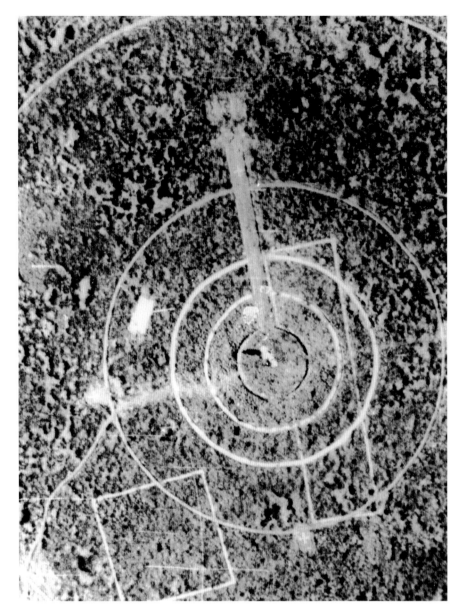

Bombing targets, or military geoglyphs, are scattered all over the countryside of southeastern New Mexico. *Courtesy of Southeastern New Mexico Historical Society.*

Part IV: The Military in Southeastern New Mexico

One of the more well-preserved geoglyphs exists outside of Hope, New Mexico. The large berms are over 6 feet high, 15 feet wide and 1,000 feet long. Most of the targets are between 1,000 and 1,800 feet in diameter. Over half of the thirty-four geoglyphs by the Roswell Air Field (RAAF), also known as Walker Air Force Base, featured a swastika or reverse swastika design and are located seventy miles east of Roswell.

Hobbs Army Air Field (HAAF) also extensively used a geoglyph that was built twenty-three miles west of the base between 1942 and 1945.

The ships on the desert features measured 800 feet long by 200 feet wide, where the ships and docks were approximately 350 feet in diameter.

Many of these geoglyphs still exist today and are an anomaly many people do not know about, even though they can be viewed on Google Earth. There is a movement to preserve remaining ones in the same category as archaeological sites. On the other side of the coin, some view these geoglyphs as suspicious, claiming some sort of alien connection.

Other military geoglyph sites in New Mexico include Clovis, Deming and Albuquerque.

New Mexico played a pivotal role in World War II; therefore, the historical military sites should be saved for future generations to learn from and enjoy. Reminiscent of the Nazca Lines in Peru, it makes one wonder what future archaeologists will think of these curious berms.

15
THE CARRIZOZO UFO CRASH OF 1947?

Poor Carrizozo. The town wasn't founded until 1899, long after Billy the Kid and the outlaw days in general were dead and gone. So, unlike its many neighbors, Carrizozo didn't have Billy, Pat Garrett or even Smokey Bear to promote. Back in the 1940s, Eve Ball wrote, "Just recently an attempt was made to open the grave at Fort Sill, and if Geronimo's body was found, to remove it to Carrizozo, reportedly for a tourist attraction. So far no attempt has been made to make the proposed removal. And it has been alleged that the little village wanted it because surrounding towns had history that drew visitors."[26]

Though Carrizozo never got Geronimo as hoped, as it turns out, Carrizozo has a tenuous connection to the famous Roswell Incident of 1947. The incident, in a nutshell, began in July 1947, when lightning may or may not have struck a craft from outer space over the J.B. Foster Sheep Ranch in Corona, NM. The remainder of the craft crashed down thirty-five miles north of Roswell, where the Roswell Army Air Field was alerted to its presence by Mack Brazel, foreman of the J.B. Foster Ranch who found the crash debris scattered across the ranch. Major Jesse Marcel was dispatched to the debris field with Brazel and collected some of the debris to take back to the base. Curiously, the RAAF released the story to the press in the form of the July 8 *Roswell Daily Record* headline "RAAF Captures Flying Saucer on Ranch in Roswell Region" and quickly redacted the story the next day with the headline "Gen. Ramey Empties Roswell Saucer" and claimed the whole thing was just a weather balloon.

Part IV: The Military in Southeastern New Mexico

Southeastern New Mexico's Greatest Legends Collide

Long before Mack Brazel became an unwilling player in the massive conspiracy that was the Roswell Incident in 1947, a relative of his, Jesse Wayne Brazel, was a willing participant in a conspiracy to kill lawman Pat Garrett in 1908. As it was, the formerly celebrated slayer of Billy the Kid had made a nuisance of himself in the Las Cruces area and acquired many enemies, among them Albert B. Fall. Legend said that Garrett was looking into the disappearances of Albert and Henry Fountain again, and lest Garrett find them, Fall and several other men orchestrated his assassination. Though well-known assassin Killer Jim Miller pulled the trigger, likeable cowboy Jesse Wayne Brazel took the blame and pleaded self-defense. The scheme went like this: Garrett had recently leased some of his land to Brazel, whom Garrett assumed would graze cattle. Instead, Brazel put goats on the land, which all ranchers, including Garrett, hated. Then Carl Adamson and Jim Miller came along from Mexico and wished to buy the land for their Mexican cattle. As the story goes, while Garrett was palavering with Adams and Brazel along a lonely road, Garrett became so angry that he went for his shotgun. Brazel had no choice but to defend himself. Strangely enough, in the coroner's report, it was revealed Garrett was shot through the back of the head. Stranger still, Brazel was acquitted, and many in the territory rejoiced over Garrett's demise, especially Fall and his cohorts. And the story gets stranger still. Some street-corner philosophers even speculated that among those who orchestrated Garrett's death was a surviving Billy the Kid living in Mexico—coincidentally the same place from which the cattle were to originate. Then Jesse Wayne Brazel disappeared several years later, his whereabouts unknown. Some folks whispered he went to Lordsburg, a southern New Mexico town rumored to have a portal in the sky that UFOs traverse in and out of. Other stories say Brazel ran off to South America, where he was shot and killed by a mysterious man known only as Dey, a known member of Butch Cassidy and the Sundance Kid's gang in Bolivia. So there you have it, the Fountain murders, the Pat Garrett assassination, the Roswell UFO Incident, Lordsburg and Butch Cassidy and the Sundance Kid together under one wild roof.

Monte Vista Service Station in Carrizozo, New Mexico, later destroyed in a jet plane crash potentially related to the Roswell Incident. *Courtesy of Johnson Stearns.*

And just where does Carrizozo enter into this tale? On Tuesday, July 18, 1947, a P-80 Shooting Star jet fighter taking off at the Carrizozo runway crashed into the Monte Vista Service Station along Highway 380, which was owned by Albert and Euda Roberts. The crash killed the pilot, Captain Soule, and one other man, Joe Drake, and badly burned both Glenn Davis and Joe Philips. How the story ties into the Roswell Incident lies with the plane's reason for taking off. Researcher J. Andrew Kissner, in his report "Peculiar Phenomena," speculated that the P-80 was ordered to stay on standby on the Carrizozo runway, which was close to the debris field in Corona being cleared away by the military at that very moment. In the case that another UFO showed up over the debris field, the P-80 would take off and provide air cover for the men cleaning up the debris field should there be an attack. The P-80 had landed in Carrizozo from March Field in California on July 15 and was there refueled by a US Army tanker truck. After this, the plane sat in wait for two and a half days until the eighteenth, when apparently there was cause for it to take off, and when it did there seemed to be no indication of trouble. The plane got 100 feet into the air and then suddenly stalled, and then veered off to the right where it crashed into the gas station, turning it into a massive fireball.

The military cover story went that the jet had made an emergency landing in Carrizozo due to running low on fuel in a rainstorm. The day after that, it refueled at the Carrizozo Air Field (which offered no refueling service in fact) and then took off and crashed into the gas station. Oddly, the story was reported in only three newspapers.

Stranger still, when the gas station was rebuilt, several of the workers there claim that to this day they can see the ghost of the dead pilot.

NOTES

Chapter 4

1. O'Connor, *Pat Garrett*, 164.
2. Metz, *Pat Garrett*, 163.
3. Ibid., 227
4. This is likely the wife of Ellis Wright, who discovered the giant footprints in White Sands, though the author cannot confirm this.
5. Metz, *Pat Garrett*, 229.
6. Initially, the grave was unmarked, but Gilliland feared it would become lost and marked it with a rock years later.
7. Metz, *Pat Garrett*, 230.
8. Ibid.

Chapter 5

9. Hendron, "Haunted House of Lincoln Town."
10. Ibid.

Chapter 6

11. Potter, "Ruidoso."
12. Ibid.

Notes

13. Ibid.
14. Colonel Jack Potter has a fascinating history all of his own and was one of the "early historians," so to speak, regarding Billy the Kid's grave. For more information, see chapter 1 of *Tall Tales and Half Truths of Billy the Kid* (The History Press, 2015) by John LeMay.

Chapter 8

15. "Apology Is Made about Snake Tale," *Ruidoso News*, n.d.
16. Jameson, *Legend and Lore of the Guadalupe Mountains*, 119–20.

Chapter 11

17. Shinkle, *Reminiscences of Roswell Pioneers*, 40.
18. Eve Ball, interview with Nib Jones.
19. "Old Mexican sheepherders" seemed to be popular figures in folktales around the area, as another features in a tale with Bottomless Lakes, also recorded by Georgia B. Redfield.
20. Redfield, "Yesterday and Today," n.d.
21. Ibid.
22. Smith, *Little Gray Men*, 29
23. Article dated March 19, 1936, HSSNM Archives.

Chapter 12

24. Indian pictures near White Sands, photographed February 16, 1934.
25. Will Robinson, "The White Lady of the Sands," in *Yucca Land*, 193.

Chapter 15

26. Eve Ball, "Sam Jones' Dog," n.d.

BIBLIOGRAPHY

Books

Ball, Eve. *Ma'am Jones of the Pecos.* Tucson: University of Arizona Press, 1969.

Burroughs, Jean. *On the Trail: The Life and Tales of "Lead Steer" Potter.* Santa Fe: Museum of New Mexico Press, 1980.

Caldwell, Clifton R. *Dead Right: The Lincoln County War.* Mountain Home, TX: Self-published, 2008.

Childress, David Hatcher. *Lost Cities of North and Central America.* Stelle, IL: Adventures Unlimited Press, 1992.

Cox, Jerry R. *Ghosts of the Guadalupes: A Factual History of Agriculture, Families and Violence Between 1905 & 1955 in Southern New Mexico.* Carlsbad, NM: Self-published, 2005.

DeArment, Robert K. *Deadly Dozen: 12 Forgotten Gunfighters of the Old West.* Norman: University of Oklahoma Press, 2003.

Fleming, Elvis E. *Treasures of History IV: Historical Events of Chaves County New Mexico.* Lincoln, NE: iUniverse Inc., 2003.

Fleming, Elvis E., and Ernestine Chesser Williams. *Treasures of History II: Chaves County Vignettes.* Roswell: Historical Society for Southeast New Mexico, 1991.

Gibson, Arrell M. *The Life and Death of Colonel Albert Jennings Fountain.* Tulsa: University of Oklahoma Press, 1965.

Howard, Jed. *Phenix and the Wolf: The Saloon Battles of Eddy and the Dave Kemp Saga.* Carlsbad: Southeastern New Mexico Historical Society, 1993.

Bibliography

Jameson, W.C. *Legend and Lore of the Guadalupe Mountains.* Albuquerque: University of New Mexico Press, 2007.

Julyan, Robert Hixon. *The Place Names of New Mexico.* Albuquerque: University of New Mexico Press, 1998.

Kazek, Kelly, and William Elrick. *Alabama Scoundrels: Outlaws, Pirates, Bandits and Bushwackers.* Charleston, SC: The History Press, 2014.

Klasner, Lilly, and Eve Ball, eds. *My Girlhood among Outlaws.* Tucson: University of Arizona Press, 1972.

Lacy, Ann, and Anne Valley-Fox, eds. *Frontier Stories: A New Mexico Federal Writer's Project Book.* Santa Fe, NM: Sunstone Press, 2011.

———. *Outlaws and Desperados: A New Mexico Federal Writer's Project Book.* Santa Fe, NM: Sunstone Press, 2008.

L'Aloge, Bob. *Ghosts and Mysteries of the Old West.* Las Cruces, NM: Yucca Tree Press, 1990.

Larson, Carole. *Forgotten Frontier: The Story of Southeastern New Mexico.* Albuquerque: University of New Mexico Press, 1993.

Lewis, Raymond. *Reminiscence of Eddy County.* Carlsbad, NM: Self-published, n.d.

McCowan, Dennis. *Goddess of War: A True Story of Passion, Betrayal and Murder in the Old West.* Santa Fe, NM: Sunstone Press, 2013.

Metz, Leon Claire. *The Encyclopedia of Lawmen, Outlaws and Gunfighters.* New York: Facts On File Inc., 2002.

———. *Pat Garrett: The Story of a Western Lawman.* Norman: University of Oklahoma Press, 1974.

Nash, Jay Robert. *Encyclopedia of Western Lawmen and Outlaws.* Lanham, MD: Rowman & Littlefield, 1992.

Nolan, Frederick. *Lincoln County War: A Documentary History.* Santa Fe, NM: Sunstone Press, 2009.

———. *Tascosa: It's Life and Gaudy Times.* Lubbock: Texas Tech University Press, 2007.

Nymeyer, Robert. *Carlsbad, Caves and a Camera.* Teaneck, NJ: Zephyrus Press, 1978.

O'Connor, Richard. *Pat Garrett: A Biography of the Famous Marshal and Killer of Billy the Kid.* Garden City, NY: Doubleday, 1960.

Phillips, John Neal. *Running with Bonnie and Clyde: The Ten Fast Years of Ralph Fults.* Norman: University of Oklahoma Press, 1996.

Ramsey, Scott, Suzanne Ramsey and Frank Thayer, PhD. *The Aztec UFO Incident.* Wayne, NJ: New Page Books, 2016.

Recko, Corey. *Murder on the White Sands: The Disappearance of Albert and Henry Fountain*. Denton: University of North Texas Press, 2007.
Shinkle, James D. *Fifty Years of Roswell History: 1867–1917*. Roswell, NM: Hall-Poorbaugh Press Inc., 1964.
———. *Reminiscences of Roswell Pioneers*. Roswell, NM: Self-published, 1966.
Simmons, Marc. *When Six-Guns Ruled: Outlaw Tales of the Southwest*. Santa Fe, NM: Ancient City Press, 1990.
Smith, Toby. *Little Gray Men: Roswell and the Rise of a Popular Culture*. Albuquerque: University of New Mexico Press, 2000.
Snorf, Annie Laurie, and Hazel Vineyard, eds. *Yucca Land: A Collection of the Folklore of New Mexico*. Dallas, TX: American Guild Press, 1958.
Sonnichsen, C.L. *Tularosa: Last of the Frontier West*. Albuquerque: University of New Mexico Press, 1980.
Stanley, F. *The Seven Rivers, New Mexico Story*. Pep, TX: Self-published, 1963.
Yadon, Laurence J., and Don Anderson. *200 Texas Outlaws and Lawmen, 1835–1935*. Gretna, LA: Pelican Publishing Company, 2008.

Articles and Manuscripts

Hendron, J.W. "The Haunted House of Lincoln Town." *New Mexico Magazine*, March 1947.
Hesse, Wally. "Capitan's Gold." *Treasure Search*, n.d.
Potter, Colonel Jack. "Ruidoso, Ghost Steer of the Pecos." *The Cattleman*, n.d.

Other Sources

Historical Society for Southeastern New Mexico Archives. Roswell, New Mexico.
Southeastern New Mexico Historical Society Archives. Carlsbad, New Mexico.
www.geneaologybank.com.
www.nearlovingsbend.net.

INDEX

A

Adams, Lytle S. 126
Allison, Robert Clay 18, 53, 55, 59
Artesia, New Mexico 23, 31, 83, 117, 120, 122
AT-11 Bombers 126

B

Baca, Juan 66, 67
Balzano Vineyard and Pumpkin Patch 31
Barnes, James 29, 30
Barrett, James 29, 30
Barrow, Clyde 32, 34, 35, 36, 37
Bataan Death March 117
bat bombs 126
Beale, Yank 28, 29
Beckwith, Henry (Hugh) 25, 26, 28
Beckwith, John 28
Bell, J.W. 49, 53, 112
Bennett, H.E. 18, 21

Bitter Lakes National Wildlife Refuge 92
Blazer's Mill 44, 58
Boellner, L.B. 69, 71
Bogener, Stephen Dean 18
Bonney, William H. 11, 25, 26, 27, 28, 32, 41, 44, 47, 49, 51, 52, 53, 55, 88, 93, 112, 128, 129
Bottomless Lakes 7, 11, 12, 87, 88, 89, 90, 91, 92
Brazel, Jesse Wayne 129
Brazel, Mack 128, 129
Brookshire, Robert 26, 61, 111, 112, 113, 114
Burnet, Bill 109
Bush, W.W. 30

C

Capitan, New Mexico 114
Cardiff Giant 63, 64
Carlsbad Army Air Field 110, 120, 123, 124, 126

INDEX

Carlsbad Caverns 89
Carlsbad Museum and Art Center 124
Carlsbad, New Mexico 17, 32, 34, 36, 37, 38, 61, 105, 111, 112, 113, 114, 120, 122, 123, 124, 126
Carrizozo, New Mexico 66, 67, 68, 128, 130
Chisum, John S. 12, 23, 41, 52, 53, 56, 59, 88, 92, 113
Civilian Conservation Corps 108, 120, 123
Coates, J.B. 61, 64, 65
Cobb, William "Bill" 35, 36
Colorado Springs, Colorado 18
Concordia Cemetery 111
Conley, William 64
Coughlin, Pat 41
Cranston, Valerie 106, 108, 110

D

Deveraux, James 30
Diamond Cave 96, 98
Dog Canyon 44, 45
Doll, E.W. 61, 64, 65
Dow, James "Les" 24, 30
Duncan, George 30

E

Eddy, Charles B. 17, 18, 29
Eddy County, New Mexico 23, 29, 30, 117, 122
Eddy, New Mexico 17, 18, 20, 21, 22, 24, 29, 30, 61, 63, 64, 65
Edmund's Act 22
Elliott, Goldie 18, 19

El Paso, Texas 17, 19, 36, 111
Enola Gay 120, 123
Evans, Jesse 52

F

Fall, Albert B. 12, 43, 129
Five-Day Battle 27
515th Coast Artillery 117
Forbidden Cave 97
Fort Stanton, New Mexico 120
Fort Sumner, New Mexico 12, 57
Fountain, Albert J. 12, 43, 44, 47, 48, 58, 73, 129
Fountain, Henry 44, 45, 47, 129

G

Gainesville, Texas 64
Gallegos, Andres 28
Garrett, Patrick F. 29, 55, 128, 129
geoglyphs 126, 127
giant rattlesnake 66, 68, 71
Gilliland, Jim 43, 45, 48, 58
Globe, Arizona 22
Gonzales, Mike 66, 67
Goodnight-Loving Cattle Trail 23
Griffith, Bill 28, 29
Guadalupe Mountains 27, 61, 64, 65, 71, 103, 105, 106, 107, 113
Guerra, Theodora 19

H

Hagerman Town, New Mexico 21
Hamilton, Raymond 34, 35, 37
Hardin, John Wesley 18, 111
Harkey, Daniel "Dee" 22

Index

Headless Horsewoman of Lover's Lane 91
Hermit's Cave 109
Hiroshima, Japan 123
hoax 64, 65, 66
Hobbs, New Mexico 120, 126
Holohan, John 30
Honey Grove, Texas 64
Hope, New Mexico 117, 126
Horton, Charlie 95, 96, 98
Howe, A.J. 61
Huntsville, Texas 37

I

Isleta, Texas 19

J

Jagtown, New Mexico 21
Jagville, New Mexico 21
Jinglebob Ranch 23, 25
Johns, Joe 34, 35, 36, 37, 38
Johnson, William H. 25, 26
Jones, Barbara 26
Jones, Heiskell 26
Jones, John 27, 28

K

Kemp, Dave 19, 30
King Saloon 22

L

Last Chance Canyon, New Mexico 105, 106, 111
Las Vegas, New Mexico 110, 114
Leck, J.B. 63
Lee, Oliver 12, 43, 44, 58
Leeper, Hugh 55
Legal Tender Saloon 18, 21
Lewis, Raymond 34
Light, Zachary 24, 25
Lincoln County Courthouse 49, 53, 112
Lincoln County, New Mexico 27, 30, 112
Lincoln County War 11, 12, 23, 25, 26, 44, 49, 52, 53, 58
Lincoln, New Mexico 27
Linn, Arthur 114
Lost River 12, 92, 94
lost skeletons 75, 77
Loving, New Mexico 120
Lyell, Ed 18, 19
Lyell, Nelly 19

M

Manhattan Project 123
Mason, Barney 55
Mason County, Texas 24
McKittrick Cave 61, 62, 112, 113, 114
McKittrick, Felix 113
McKittrick Hill 61, 113
McNew, Jim 43, 44, 45, 48
Meadows, John 44
Methvin, Henry 37
Montgomery Ranch 106
M'Rose, Beulah 18
M'Rose, Martin 18
Mulhoon, William L. 30

N

Nesmith, George 41

INDEX

New Mexico State Hospital 110, 114
Norden, Carl 123
Norden Mark XV Bombsight 123, 124

O

Odessa, Texas 37
O'Hearn, Jim 122
Old Ruidoso, the ghost steer 52, 53, 56, 57, 58, 60
Olinger, Bob 28, 49, 53, 58, 112
Orchard Park Camp 120, 122
Otis, New Mexico 120

P

Parker, Bonnie 32, 34, 35, 36, 37, 38
Pecos River 111
Pecos, Texas 23, 36
Pecos Valley Town Company 17, 18
People's Mercantile 34
petrified man 61, 62, 63, 64, 65
Phenix, New Mexico 17, 18, 19, 20, 21, 22, 61, 64
Philbrick, C.H. 18
Pickett, James Henry "Jim" 105, 106, 107, 108, 110, 111, 114
Pickett, Tom 28
Pierce, Milo 28
pontoon crossing 111
Potter, Colonel Jack 56, 57
prisoners of war 119, 120, 122, 123
Project X-Ray 126

Q

Queen, New Mexico 105, 106, 108, 109

R

Redfield, Georgia B. 49, 92
Reed, William Daken 23
Rhodes, Alfred 18
Robinson, Will 87, 100
Rocky Arroyo, New Mexico 28, 111
Roswell Air Field 120, 127, 128
Roswell Incident 11, 120, 128, 129, 130
Roswell, New Mexico 11, 13, 52, 56, 69, 71, 75, 80, 87, 89, 91, 92, 94, 96, 97, 98, 111, 114, 120, 126, 128
Ruidoso, New Mexico 41, 67, 79, 81, 82
Rule, Richard 20

S

Samson, Capt. Sam 23
San Antonio, Texas 36, 37
Schwab, Jake 30
Seven Rivers Cemetery 111
Seven Rivers Crowd 23
Seven Rivers, New Mexico 23, 24, 25, 26, 27, 28, 29, 31, 111, 112, 114
Seven Rivers Warriors 25, 26, 28
Sheldon, Gov. Lionel 29
Silver King Saloon 18
Silver Spur Saloon 20
Stamp, Dorsie M. 34

Stamps, Dorsie M. 34
Stamps, Millie 34, 35, 36, 38
Stone, William 30
Sullivan, Dan 29, 30

T

Tomlinson, James A. 18
Torrini, Pascal 64
Tularosa, New Mexico 120
Tulia, Texas 64
Tulk, J.W. 108
Twin Oaks Cemetery 31
200th Coast Artillery 117

V

Valley of Fires 66

W

Wallings, Hade 64
Ward, John 64
White Oaks, New Mexico 18
White Sands 41, 43, 47, 58, 73, 83, 99, 100
Williams, Johnnie 107, 108
Wilson, Billy 28
Wilson, Pony 28
Wortley Hotel 112
Wright, Ellis 99

Y

Younger, John 64

About the Authors

As a native of southeastern New Mexico, Donna Blake Birchell, author of *Wicked Women of New Mexico*; *McKittrick Canyon: A Beautiful History*; *New Mexico Wine: An Enchanting History*; and *Carlsbad and Carlsbad Caverns*, among others, has heard many stories of the fanciful events that have occurred in the area in the far—and not so distant—past, and wanted to share these with you, the reader. As a collector of history, Birchell's greatest pleasure is to reveal times past with those who share her passion.

John LeMay is the author of such books as *Tall Tales and Half Truths of Billy the Kid*; *The Real Cowboys and Aliens: UFO Encounters of the Old West* with Noe Torres; and *The Big Book of Japanese Giant Monster Movies: Vol. 1 1954–1980*, to name a few. He is also the writer/producer of the short documentary *An Introduction to the History of Roswell, New Mexico* with Relicwood Media and is a past president of the Historical Society for Southeast New Mexico Board of Directors.

Visit us at
www.historypress.net

This title is also available as an e-book